I ND DESIG

D1492067

Martine Franck
by Louise Baring

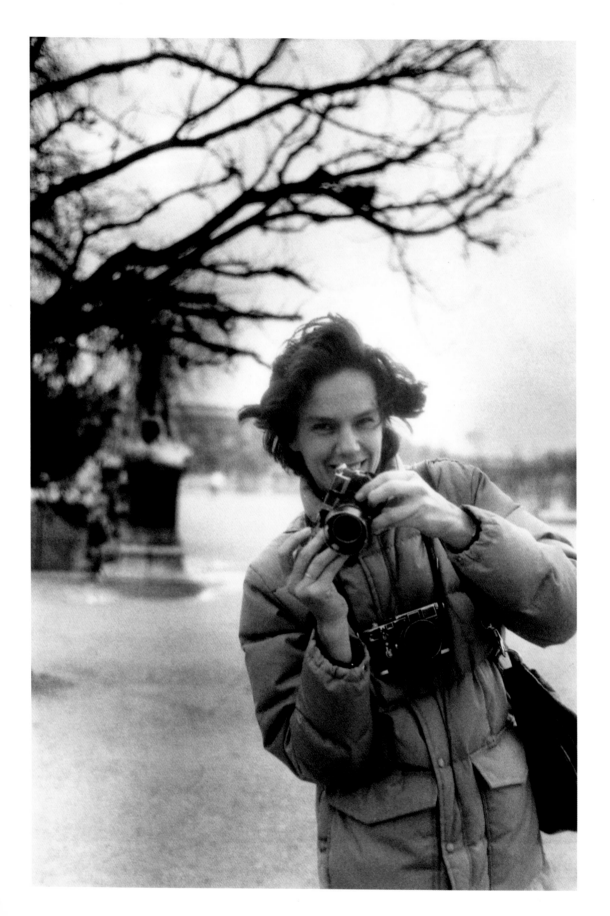

One of the few female members of the Magnum photographic agency – the cooperative founded by Robert Capa, Henri Cartier-Bresson, George Rodger and David 'Chim' Seymour in 1947 – Martine Franck brings aesthetic rigour and a feminine sensibility to the humanism that characterizes the Magnum philosophy. Her black and white photographs, whether of exuberant children at play, street carnivals, evocative landscapes or startling geometric studies, have received international recognition. They have featured in *Life*, *Vogue*, *Le Monde* and the *New York Times* as well as in over a dozen of her own books and in exhibitions across the world. Describing photography as 'a barrier that one is constantly breaking down, so as to get closer to the subject', Franck also finds and develops specific themes. She focuses on those who live on the margins of society or in isolated communities, often returning to a subject time after time: refugees in Sudan, child reincarnations of Tibetan lamas, Gaelic-speaking communities in Ireland or tender portraits of old people hidden away in homes. Devoid of artifice, her work reveals compassion and curiosity about her fellow humans, while retaining a classical purity rooted in her love of painting and training in art history.

Unlike many of her fellow photographers, Franck was slow to pick up a camera. She was born in Antwerp, the daughter of Louis Franck, a Belgian banker who made his career in London, and his wife Evelyn. At the outbreak of World War II her father joined the British Army while the rest of the family set out for the United States, where they lived on Long Island and then in Arizona. Revealing a strong visual sense from childhood,

Martine Franck by
Willy Ronis, 1980

Franck tells the art critic and writer John Berger in the foreword of her retrospective exhibition catalogue, *One Day to the Next* (1998), how her first memories were of the Californian desert: 'Huge fierce cacti, erect rocks, sand, dried up river beds – almost monochrome apart from the occasional tiny flower.'

It was Louis Franck who first introduced his daughter to the pleasures of looking at art when the family returned to live in London after the war. Visits to museums and art galleries on Saturday mornings became a highlight of the week: 'My grandfather, who was a friend of Belgian painters like James Ensor and Rik Wouters, loved to collect. My parents in turn continued, buying pictures by Flemish and French artists.' Assuming that she would work in an art gallery or museum, Franck studied history of art at the University of Madrid, and then at the École du Louvre in Paris where she wrote her thesis on the influence of cubism on sculpture and Henri Gaudier-Brzeska – an avant-garde French-born sculptor who died, aged twenty-four, in World War I.

Writing her thesis made Franck realize that she did not want a career as an art historian or a museum curator, longing instead to go out and create something herself, though she knew that she had no gift for painting or drawing. Her opportunity came when, at the age of twenty-six, the end of a love affair prompted her to take a sabbatical to China: 'Few Westerners could obtain visas at the time, so my cousin told me to take photographs and lent me his Leica. I remember that I was so ignorant about photography that when I took the Trans-Siberian Express, I didn't even realize that you could take photographs when the train was moving.'

Travelling onto Japan, Franck joined Ariane Mnouchkine, whom she first met as a teenager in Switzerland. The daughter of a film producer, the theatre director Mnouchkine had not yet created her theatre troupe, the Théâtre du Soleil, though

movement already fascinated her. More importantly for Franck, Mnouchkine was a good photographer who knew a lot about cameras: 'It was with Ariane that I bought my first camera in Japan and it was she who taught me how to use it, while we made a photo journal of our trip. She explained to me about aperture and shutter speed – I had no idea of the technicalities.'

Returning to Paris via Hong Kong, Cambodia, India, Afghanistan and Turkey, Franck knew she wanted to become a photographer. 'I think I was shy as a young woman and realized that photography was an ideal way of expressing myself, of telling people what is going on without having to talk.' It is this 'shyness' combined with an innate tact which have enabled her to take gently revealing portraits or to photograph people who might normally perceive the presence of a camera as an unwelcome intrusion: a wedding at an orthodox Jewish synagogue, a couple embracing (no. 30), young dancers as they relax during a break in their rehearsal (no. 34) or Tibetan monks during a debating session (no. 51).

What is essential in documentary photography is to bear witness and to convey this to other people. Franck's unthreatening presence plays an essential role: 'Once people ask you to take their photograph, then you know that you have been accepted.' Franck prefers the evocative quality of black and white photography, which allows a slight distance from her subjects, finding colour too realistic or 'kitsch' for her classic style.

As she began working in 1964, Franck was inspired by the work of Julia Margaret Cameron, Dorothea Lange and Margaret Bourke-White, whose precedent encouraged her to believe that it was possible to succeed as a female photographer. But her mentors were Eliot Elisofon and then Gjon Mili, an Albanian-born photographer, who took Franck under his wing on her arrival as an assistant at the Paris office of Time-Life. 'Mili was a brilliant technician who had worked for the famous film director,

Ernst Lubitsch. I always remember him saying to me: "Martine, you have to copy me first, then once you know how to copy me, you can go your own way".' A year later she launched herself as a freelance photographer. One of her early works, *Children's Library* (no. 01), contains some of the essential elements of her style: warmth, clarity and a fascination with abstract shapes.

Franck's lifelong love of disguise and such spectacles as festivals, street carnivals and the stage, when humans can mask their true identities is also already clear in early images like *The Clowns* (no. 02). The actors pictured are from the Théâtre du Soleil and Franck has been photographing the cooperative's work since its founding by Mnouchkine in 1964. The company presents highly original productions of works by Shakespeare, Greek tragedies and plays by Hélène Cixous, and Franck's collaboration with Mnouchkine has evolved into four books and a string of exhibitions (including her first, held in Paris at the Galerie Rencontre in 1971) as well as a short film, *Ariane et Compagnie* (Ariane and the Company), which Franck made with Robert Delpire in 1995. Mnouchkine's vivid references to Japanese *kabuki* and Indian *kathakali* theatre, oriental and contemporary dance as well as *commedia dell'arte* are so stylized and divorced from reality that Franck felt compelled to make a rare switch to colour to give these images what she calls a 'visual emotion'.

In 1970 Franck joined VU, a photographic agency in Paris that broke up within a year of her arrival when the founding director, Pierre de Fenoyl, left for the United States. The only woman among the seven remaining photographers, Franck went on to co-create a new agency, VIVA, in 1972: 'We had the same kind of ethos as at Magnum, except that we all lived in Paris and all did the same type of black and white photography.' Eschewing the tough, solitary life of a foreign news reporter often on the road for weeks on end, she turned her lens to some of the other themes that run through her work: old age, children, landscapes and portraits.

It was French *Vogue* who, in 1967, commissioned Franck's first portraits – women in French cultural life, including Ariane Mnouchkine and the photographer Sarah Moon, a theme she returned to in the early 1980s when the French minister for women's rights asked her to undertake a similar project on a larger scale. 'I always feel a bit scared before the first shot, then slowly we start talking. What I try to capture is the light in a person's eyes, a gesture, a moment when they're listening or a look of concentration – precisely the moment when they are not talking.' A large number of Franck's portraits over the years have been of artists: Marc Chagall as he reveals all his knowing charm (no. 37), Paul Strand with his unwieldy view camera (no. 05) or a pensive Balthus sitting with his Burmese cat (no. 54).

In 1966, Franck was introduced to Henri Cartier-Bresson – acknowledged by many to be the greatest twentieth-century photographer – and they married in 1971. The couple led a life surrounded by artists and photographers, including fellow members of Magnum. Except for a trip to the former Soviet Union in the year of their marriage, they never photographed together, but always showed each other their work: 'Henri was both critical and inspirational as well as warmly supportive of me as a photographer.' Franck was nevertheless resolute in her refusal to profit professionally from her marriage, even cancelling her first exhibition – at the Institute of Contemporary Arts in London in 1970 – when she learned that the invitation mentioned that Cartier-Bresson would be present at the private view.

Since Cartier-Bresson's death in 2004, Franck has done much to preserve his artistic legacy. In 2003, she opened the privately-funded Fondation Henri Cartier-Bresson with her husband in Paris to showcase his work and to house his archive of vintage prints, contact sheets, rare books, films and posters, amongst other material. The foundation also provides opportunities and information for both new and established documentary photographers and film-makers who share the

Magnum ethos. In recognition of the significant role that she has played in French cultural life, Franck was awarded the Chevalier de l'Ordre National de la Légion d'honneur in 2005.

In 1971, Franck briefly abandoned photography for film-making, travelling to the United States to make two documentary films, *Music at Aspen* and *What has Happened to the American Indians?* Her fellow photographers at VU, however, managed to lure her back to the agency. Photography gave Franck a physical and artistic freedom unfettered by film production companies and tight schedules. Rather than the precise framework needed to tell a story in film-making, Franck prefers the evocative nature of photography, working with no preconceived idea of what she will do. After VU closed down, she remained with VIVA until 1979, when she left to focus her energies on her project on old age.

Franck was content to explore an unfashionable yet universal theme even though she knew it would be hard to find a publisher for the photographs. This project on the isolation, indignities, as well as the intimacies of old age reveals her understanding and humour: a woman appears lonely and detached as she sits in her Avignon hospice (no. 10), an eccentrically dressed lady stands clutching an American flag at the Veterans' Day Parade in New York (no. 12) or four proud war veterans appear at their grand home, The Royal Hospital in Chelsea, London (no. 14).

Franck's project on old age, *Le Temps de vieillir* (A Time to Grow Old), was finally published in Paris in 1980. Reviewed as a sensitive, compelling portrait of a whole segment of society that is often pushed aside, the book marked the start of her being appreciated as a photographer in her own right. That year Franck also became an associate of the Magnum photographic agency, knowing that her photographs would be better publicized and distributed to newspapers and magazines throughout the world. She remained with Magnum, becoming a full member in 1983.

Notoriously difficult to enter, Magnum puts its would-be members through a rigorous selection process. To this day, only a tiny handful of the full members of the cooperative are women. Franck, who was vice president of Magnum from 1998 to 2000, ascribes the lack of women in part to the tough, competitive nature of the profession. Her own domestic obligations, including motherhood (the Cartier-Bressons have a daughter, Mélanie), precluded lengthy stints abroad. Instead, she has focused on the subjects closest to her heart: portraits, landscapes, theatre, women at work, and on long-term projects with a humanitarian theme, often returning to places like Nepal, India or Ireland for two or three-week periods.

However, it would be wrong to view her images as sentimental. For Franck, taking a photograph involves solving compositional problems on the spot – she never improves an image by cropping in the darkroom – as well as capturing an unexpected, fleeting moment. Like, for example, her picture of an Indian child flying through the air as she jumps from one boat to another (no. 36): 'Composition in photography is in a way intuitive because you don't have the time, but obviously you have to recognize all the elements. It's a familiarity that comes with art training.' As Berger puts it in his foreword to *One Day to the Next*: 'The old woman in Ivry (no. 16) joking with you about the picture you are about to take, is using the right tense: future immediate … you are waiting for what is going to happen unpredictably.'

Though fascinated by the idea of capturing a millisecond in time, Franck has also always felt compelled to take photographs of landscapes, many of which reveal her mastery of light and a reflective side to her nature. The isolation evoked by a photograph of Hadrian's Wall (no. 29) is relieved only by a light in the window of a shepherd's cottage on the edge of a copse. Her taste for geometric patterns is revealed in her image of a swimming pool in Le Brusc, Provence (no. 22), with the criss-crossing lines of the hammock in the foreground shadowed on the square tiles

below, while the curved edge of the terrace punctuated by decorative white globes stands out against a dark slope. Franck's portrait of two Irish girls jumping hand in hand off a wall on the beach in Tory Island (no. 49) conveys a nostalgia for a traditional way of life without ever losing sight of the need for a strong composition, linking form and content: 'It's very hard to get a decent picture, but if you do, you realize it immediately. There are very few surprises when you examine the contact sheet, or once a print has been made.'

One of the pleasures of photography for Franck is its ability to record the passage of time. She often takes her photographs with her on her return to places she has already photographed, so that she can share them when she meets up with her subjects. Franck first visited Ireland in 1993 to photograph a community of travellers who had settled in the Ballymun and Darndale housing estates in the north of Dublin. 'I have always been interested in minorities, in people who are in difficult situations trying to preserve their lives – people should have the right to lead the lives they want.' She also became involved in portraying two groups, both poor and living off state benefits, yet leading totally different lives. The contrast could not be sharper between a scene of destruction in her photograph of a graveyard for stolen cars in Darndale (no. 48) and her lyrical study of Tory Island, a dwindling, tranquil community of 130 Gaelic-speaking people living off the coast of Donegal, which was also the subject of a French television documentary that Franck made with Fabienne Strouvé, *Retour en Irlande* (Return to Ireland, 2000).

Franck first went to Tory Island in 1993 with Derek Hill – an English painter and a frequent visitor to the island – in search of a community to photograph for a project on exclusion in Europe initiated by Les petits frères des Pauvres (The Little Brothers of the Poor), a charity that helps the lonely or the isolated, especially the elderly. She has followed and

participated in the charity's work for many years, contributing to their mission through her documentation of these groups of people.

On arriving at Tory Island, Franck was immediately taken with the unique qualities of the island and its people. Refusing to abandon their treeless, windswept home for the mainland, Tory Islanders eke out an existence by fishing and rearing sheep. Most survive on supplies brought to them by ferry – as seen in Franck's image (no. 47) taken from the stern of the boat with the mainland in the distance. The island depends on this lifeline even though winter storms sometimes cut them off for days. Franck's photographs, taken in the clear northern light, reveal the island's bleak beauty, while her portraits – whether of the lighthouse keeper, a fisherman or the vibrant faces of the two little girls jumping off a wall – also reveal what Franck describes as 'the islanders' deep sense of identity and determination to remain in the place where their families have lived for hundreds of years'.

Franck's intimate portrayal of the Tory Island community is similar in tone to her photographs of Tibetan tulkus. As the French critic Gerard Macé points out in the catalogue to Franck's 2002 exhibition at the Musée de la Vie Romantique in Paris: 'On looking closer at Franck's photographs, you realise that her characters – whether by birth or by choice – almost all belong to a small community. They are merely the transient expression (but all the more precious for that) of something that they themselves are unaware of, but which without them would be lost for ever.'

Like the Tory Islanders, Franck's tulkus also live secluded from the rest of the world. Her photographs, taken in Tibet, India and Nepal, are part of a project on which she focused from 1993 to 1998. Breaking into a new realm, they depict a handful of young boys – one of whom was even discovered in Spain – who

01 1965 Children's Library, Clamart, France.

Although she seldom poses her photographs, Franck agreed to her editor's request for a strong opening photograph to a *Life* magazine story on the first children's library in France, designed by Gérard Thurnauer of the Atelier de Montrouge. With their inquisitive faces peering over the edge of the white, snail-shaped staircase, the neatly arranged children form a composition that appears to stretch into infinity.

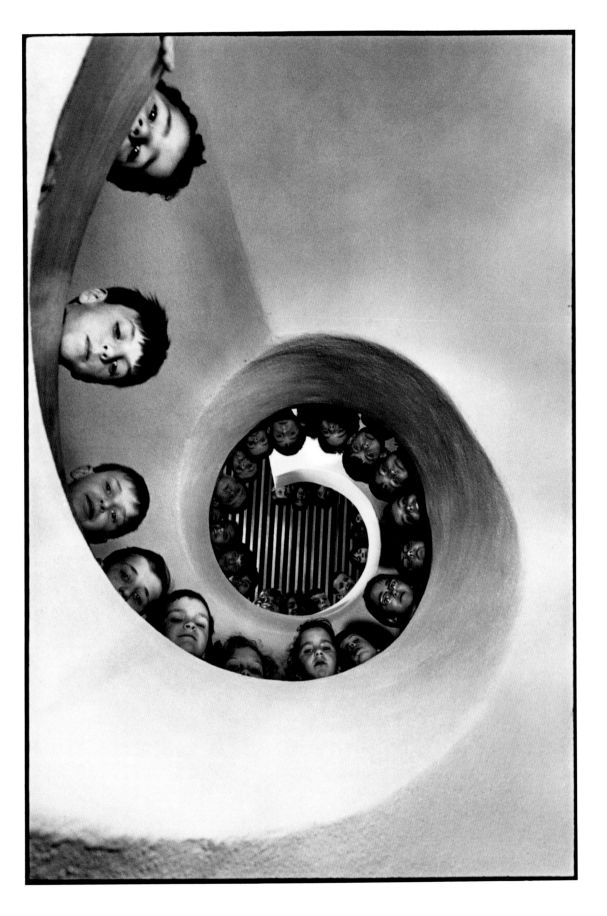

1969 The Clowns (Joséphine Derenne and Mario Gonzales), Théâtre du Soleil, Aubervilliers, France.

Franck has been photographing the Théâtre du Soleil at work since Ariane Mnouchkine formed her theatre troupe in 1964: 'I try to show the complex evolution of her different productions by photographing rehearsals rather than actual performances.' The marks on this image were caused by condensation – a result of keeping film in a fridge that was too cold. Nevertheless, together with the ageing stage décor in the background, they add to the photograph's slightly melancholy atmosphere.

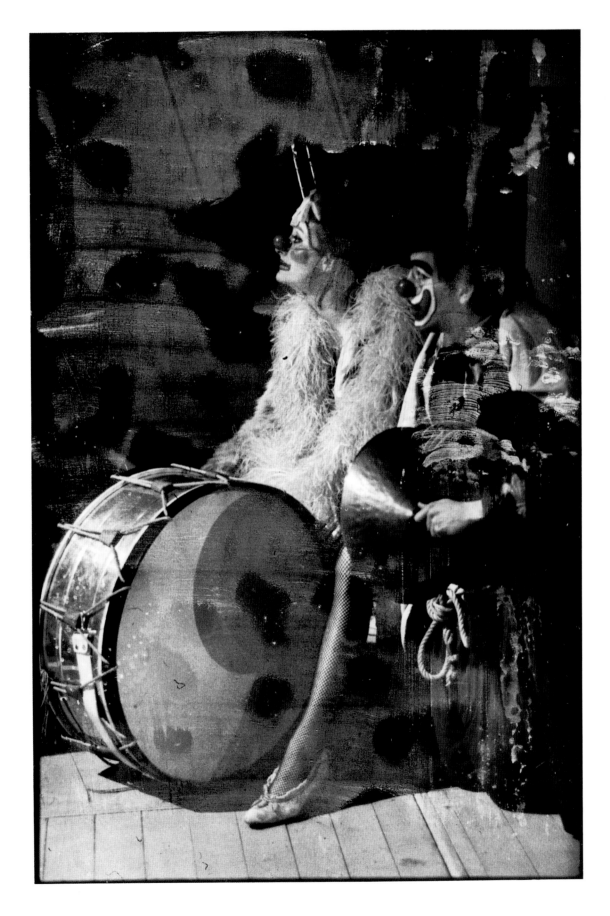

03 1970 | Funeral of Charles de Gaulle, Colombey-les-Deux-Églises, France.

Despite the demonstrations and strikes of May 1968 and the defeat of his referendum in 1969, the former French president Charles de Gaulle was a paternal figure in the eyes of the nation and his death prompted an outpouring of grief. While newspaper photographers climbed trees to capture the funeral procession itself, Franck photographed a young woman wrapped in shawls, her sorrowful expression reminiscent of a *pietà* from the Italian Renaissance. The image was later reproduced on the cover of the British photography magazine, *Creative Camera*.

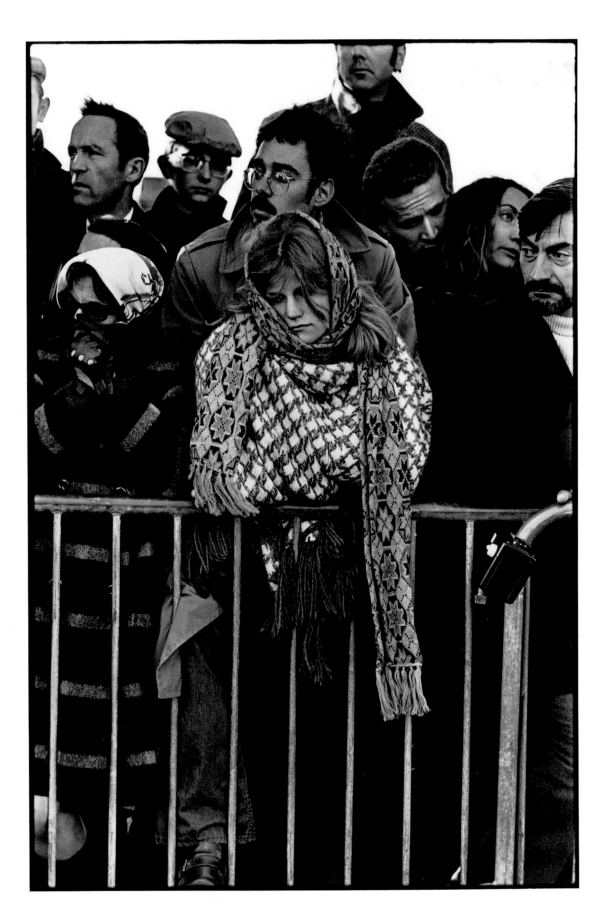

04 1971 | Pisticci, Basilicata, Italy.

Franck enjoys photographing landscapes, describing it as 'an exercise in visual meditation', in contrast to the split-second snapshot. The stillness of this bare landscape, photographed outside a remote village in southern Italy, is disturbed only by a gaggle of geese accompanied by a dog: 'I often use an animal or human element in my landscapes to lend an element of surprise.'

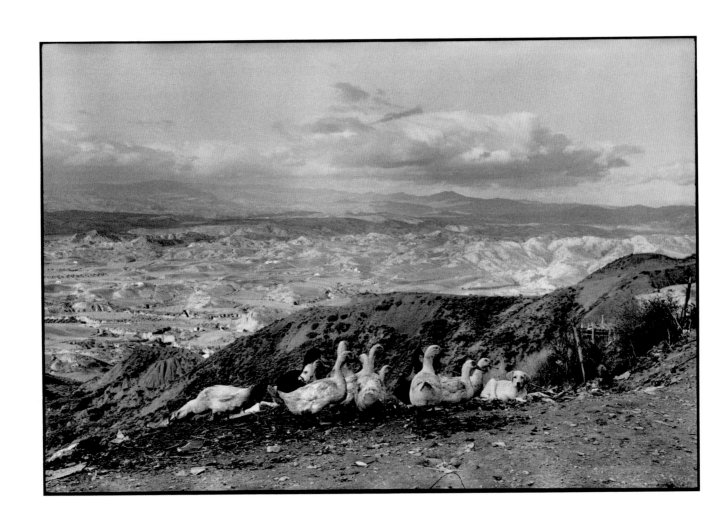

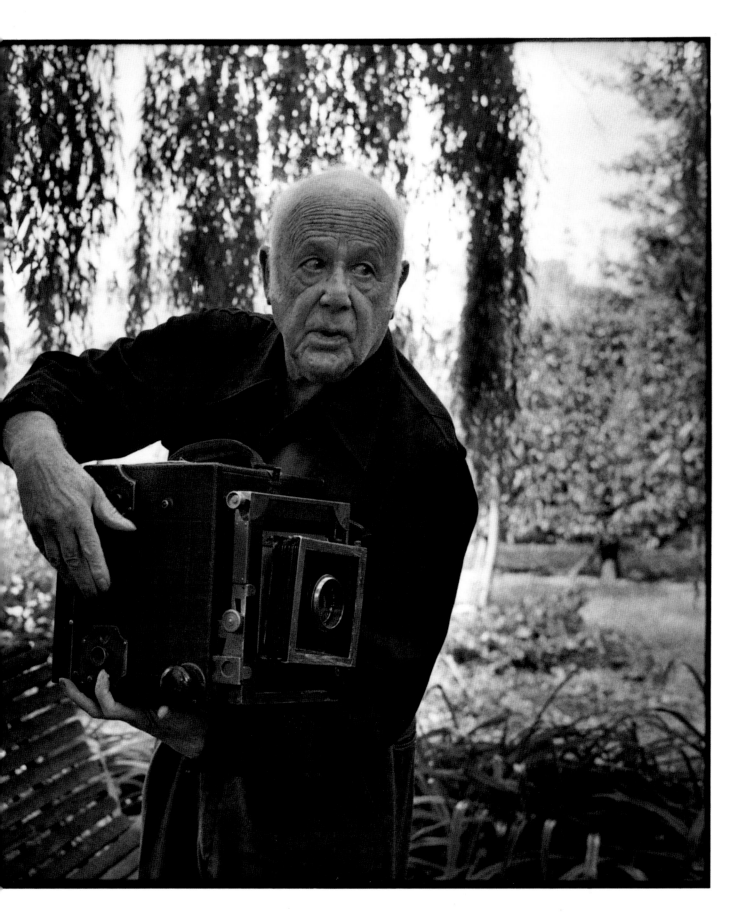

05 *previous page* 1972 Paul Strand, Orgeval, France.

One day, Franck and her colleagues at VIVA received a letter from the American photographer Paul Strand congratulating them on their work. Franck, who has always been passionate about portraiture, replied, asking if she could take his picture. Then in his eighties, Strand had lived in France since the McCarthy era, creating a corner of New England just outside Paris. Here she pictures him standing in his garden, clutching an unwieldy turn-of-the-century camera, his photographer's eye caught by something in the distance.

06 1972 Exhibition of Belgian Art, Paris, France.

Franck has always been intrigued by the different ways in which people look at art, so she accepted a request from the Belgian Consulate to photograph visitors at the exhibition 'L'Art Belge' at the Musée du Jeu de Paume in Paris. Unaware that he is being photographed, the middle-aged man leaning forward as he peers at a work by Paul Delvaux looks as though he could belong to the painting itself.

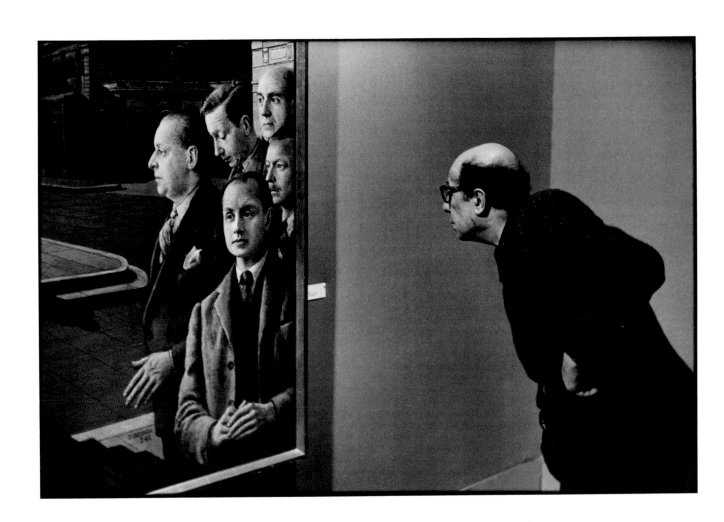

1973 Les Petites-Dalles Beach, Normandy, France.

This sombre photograph was taken by Franck as darkness began to fall one winter afternoon on the Normandy coast. Like many of her landscapes and seascapes this misty image, with the last rays of light catching the edge of the water, is one of total solitude: 'As the old woman wandered alone along the pebble beach, I felt almost that she was going to walk into the sea.'

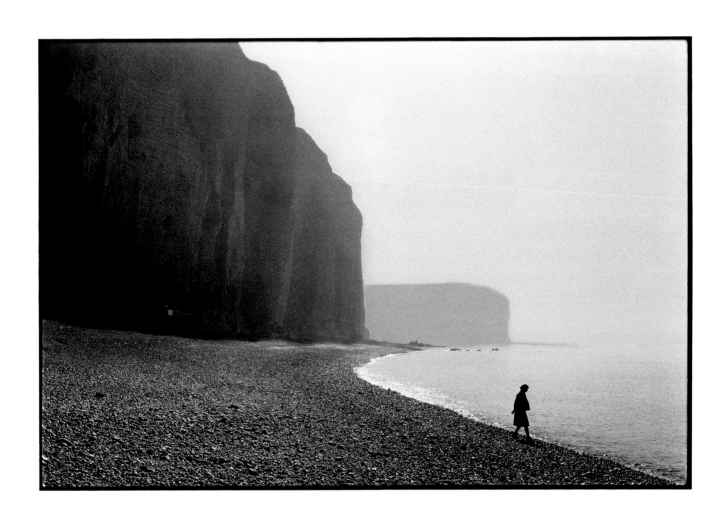

1973 Princess Anne's Wedding, Parliament Square, London, England.

On the day of Princess Anne's wedding, a woman and her grandchild stand outside Westminster Abbey, happy to wait for hours before the arrival of the royal bride. The imposing presence of the statue of Winston Churchill further accentuates the gulf between the ordinary public and the grandeur of the event they are about to witness: 'There was still this uncritical admiration for royalty thirty years ago,' remembers Franck. 'For the French it was so amazing that people should react like that.'

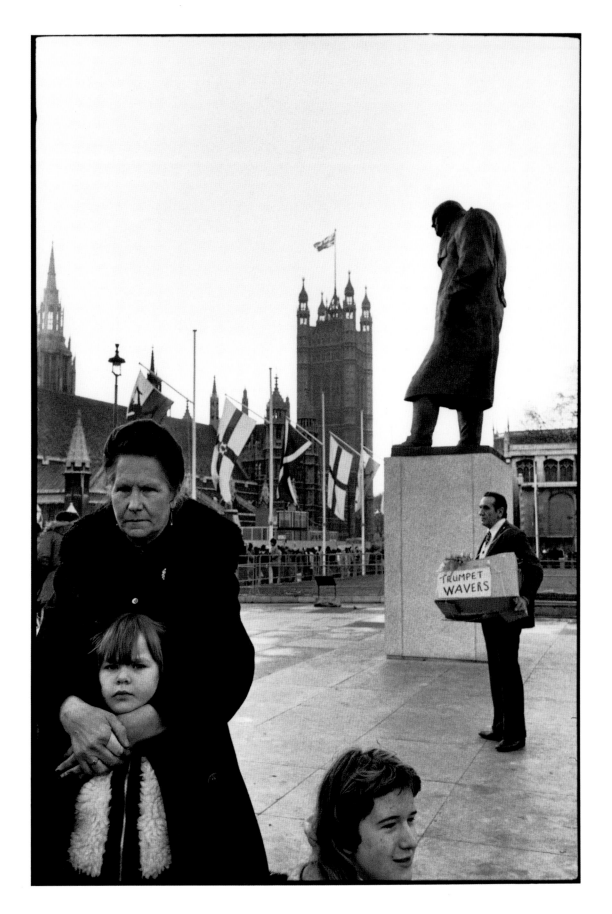

1974 Jean-Louis Scherrer Fashion Show, Paris, France.

One of Franck's first commissions for the *New York Times* was to cover the fashion shows in Paris – at that time relatively sober events compared to the junkets of today. Although she has never been a fashion photographer, Franck nevertheless captures the show's typical Parisian elegance as the models' silvery white 1930s-style dresses contrast with the dark figures reflected in the tall mirrors behind.

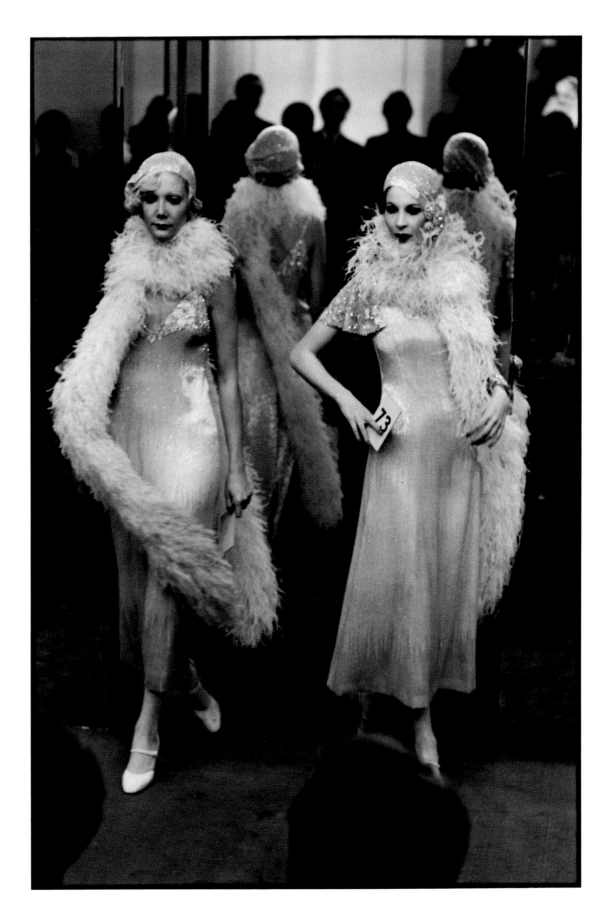

10 1974 Saint Louis Hospital, Avignon, France.

Touched by the plight of the elderly, Franck started photographing them
– a project later published in a volume entitled *Le Temps de vieillir* (A Time
to Grow Old) in 1980. The woman pictured here lived in a seventeenth-
century hospice for the elderly in Avignon. The position of her chair conveys
the sense of isolation experienced by so many old people: 'I was then
still young enough to confront old age without anxiety,' explains Franck.
'I remember promising myself that I wouldn't grow old like that.'

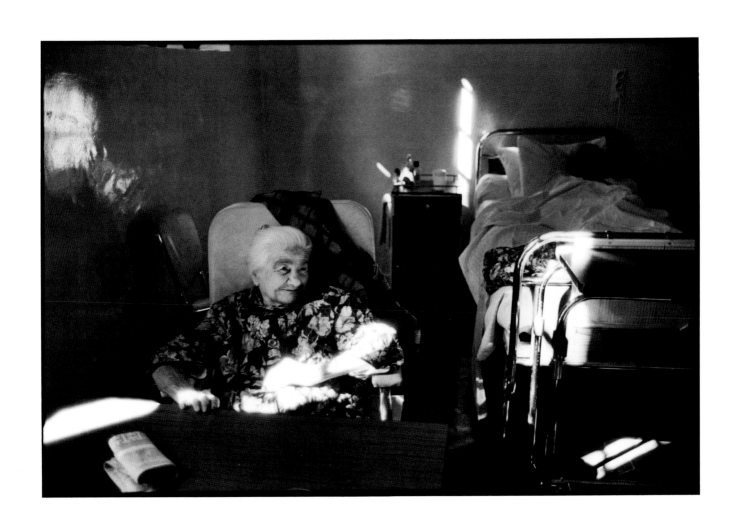

11 1974 Village Festival, Sivergues, Provence, France.

Franck has often photographed the annual religious festivals of many
Provençal villages. They usually include a parade and a large communal
meal outdoors, but when Franck arrived on this occasion, a complete
hush had fallen over the entire village: everyone had gathered round
a television set to watch France play in the World Cup. The viewers
are transfixed, almost as in a religious gathering, and this photograph
has often been used to illustrate the power of television.

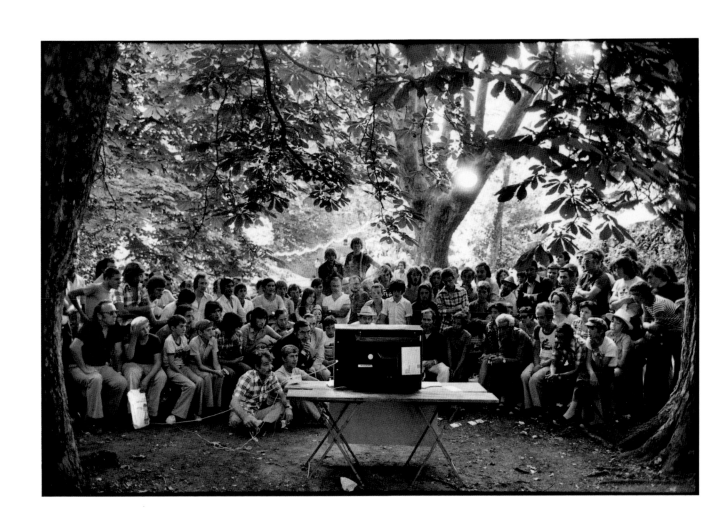

12 1974 Veterans' Day Parade, New York, USA.

While working on her project on old age, Franck travelled to New York where she photographed the annual Veterans' Day parade on 11th November. In Central Park, she spotted an elderly woman standing off from the group wearing a wig, white gloves, lace cap and clutching the American flag. One of several pictures of this woman taken by other Magnum photographers, the triangular composition of Franck's version – the comparatively young band players clearly oblivious to the older woman's presence – emphasizes her isolation.

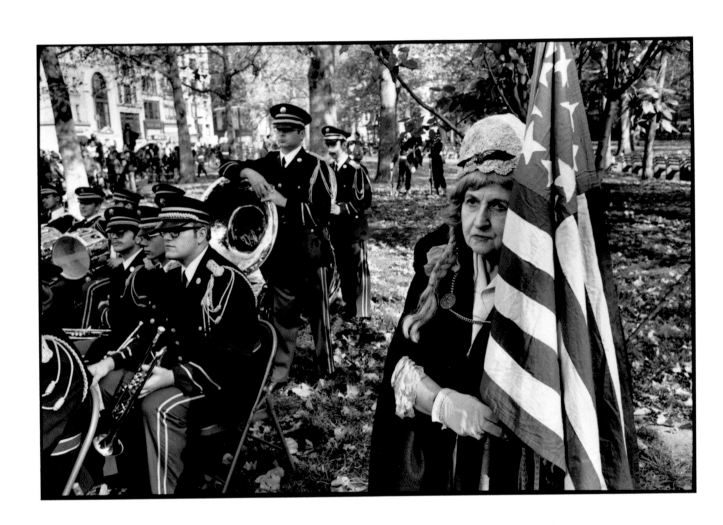

13 1975 Saint-Siffrein Fair, Carpentras, France.

The Saint-Siffrein Fair, which takes place in the town of Carpentras before Christmas every year, is one of the largest in Provence. Dating back to the Middle Ages, it is well-known as a market-place for black truffles. In this photograph, Franck contrasts the sturdy haunches of the horses, their tails neatly tied up and decorated, with the delicate shadow of the tree, its leaves rustling in the breeze.

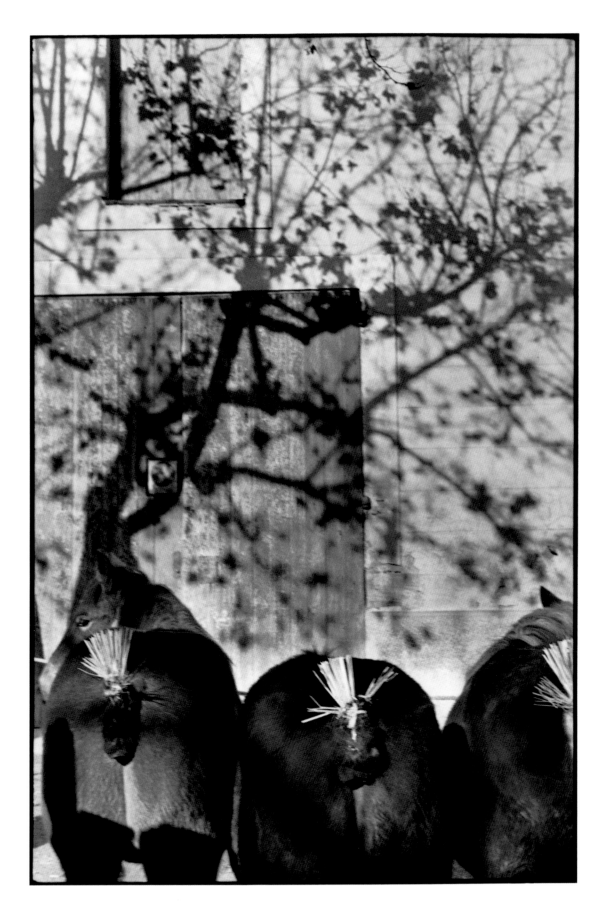

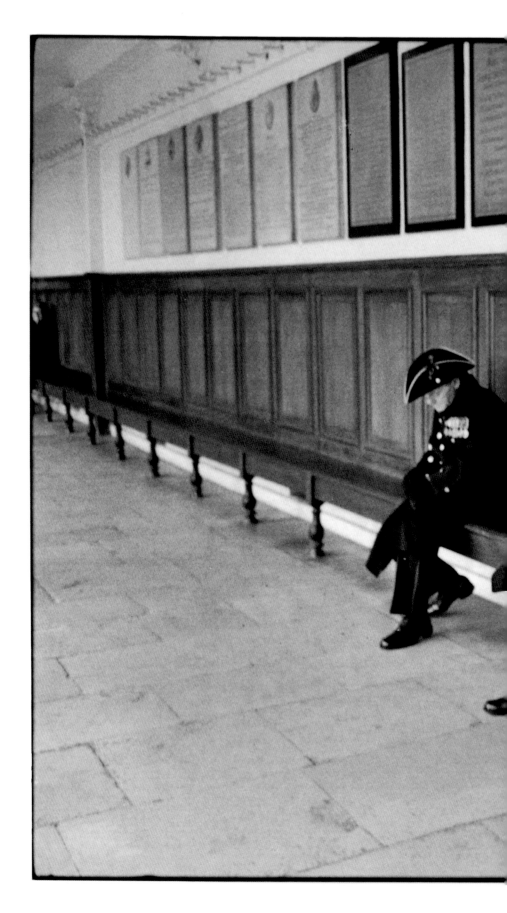

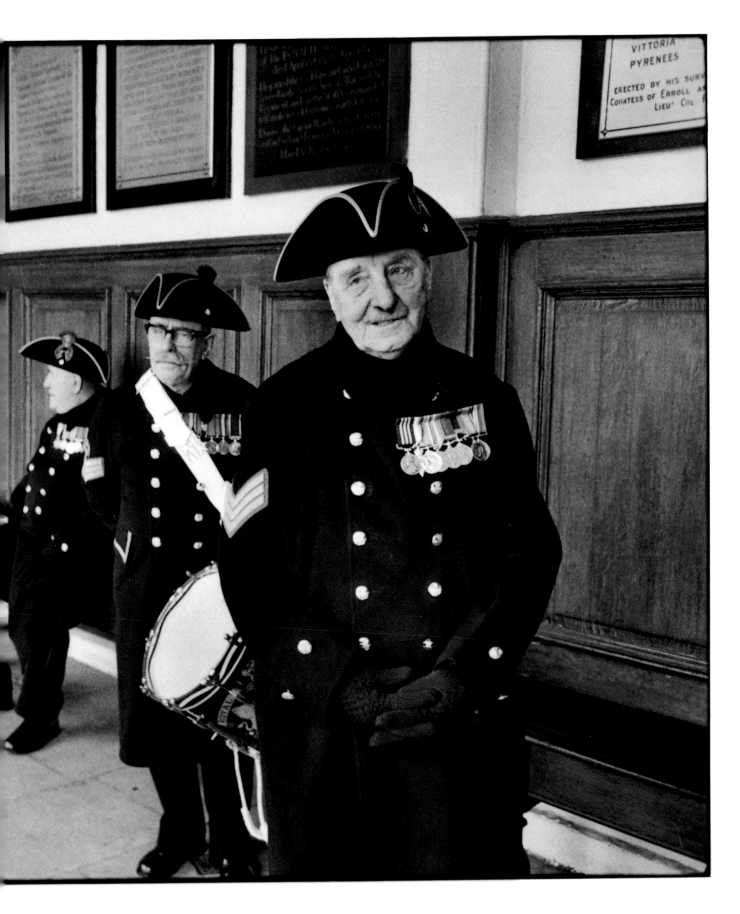

14 *previous page* 1975 | The Royal Hospital, Chelsea, London, England.

This is a more optimistic portrait of old age than some of Franck's other images. The ex-servicemen are proud to be photographed in their resplendent uniforms, set against the perspective of a grand corridor in their seventeenth-century home, which was designed by Sir Christopher Wren. 'I was fascinated by their ritualistic way of life in these magnificent surroundings. It was an extraordinary sight,' she recalls.

15 1975 Carnival, Binche, Belgium.

'As a photographer, it is always exciting to be taken by surprise just walking down the street,' says Franck. She took this snapshot as she glanced through a café window in a small Belgian town during carnival time just before Lent – festivities that she sees as a form of street theatre. The gesture of the young boy with his lace cuffs, ruff and plumed hat as he holds a potato crisp in his hand is reminiscent of portraits by the seventeenth-century Dutch painter, Frans Hals.

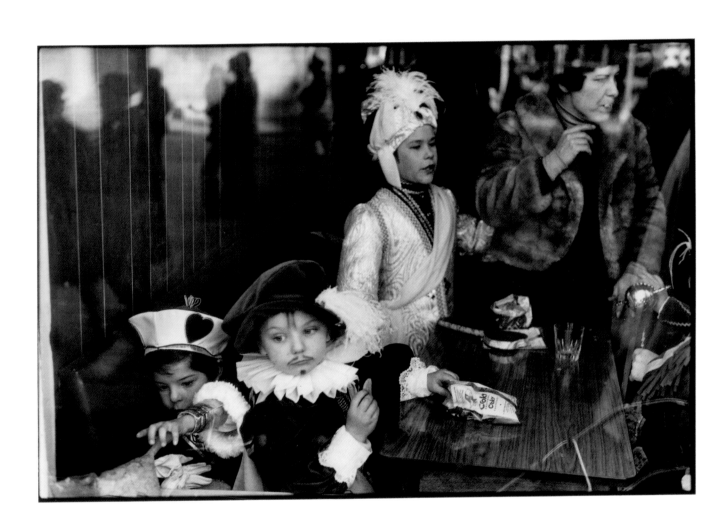

16 1975 Ivry Hospice, Ivry-sur-Seine, France.

Franck came into contact with 'Les petits frères des Pauvres' – a charity that is best known for its work supporting elderly people – through working on her book *Le Temps de vieillir*: 'They soon realized that photography could help change public attitudes towards old age,' she explains. The old woman shown here is playfully mimicking the photographer taking her picture. However, once that brief moment had passed, Franck recalls, she retreated back into her own world.

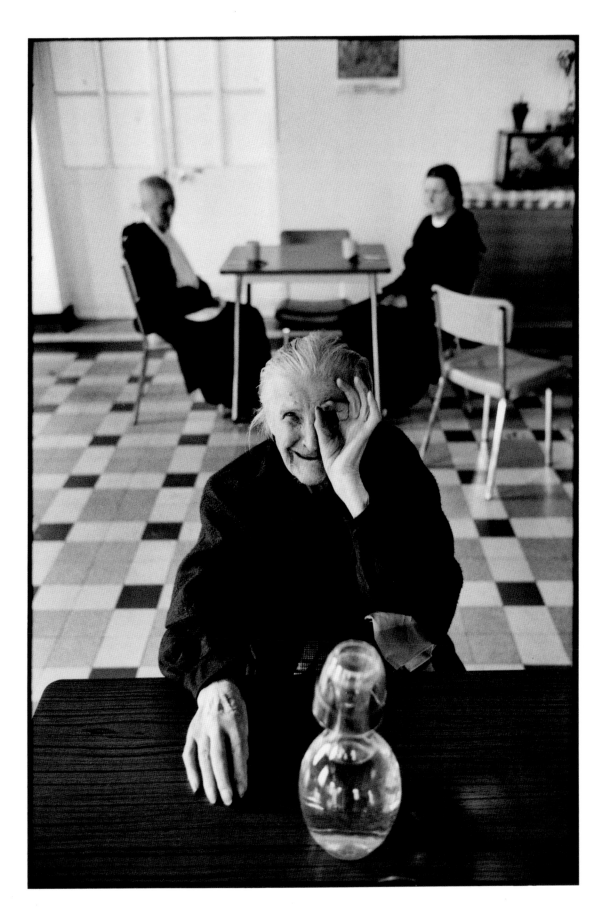

1975 Spring Festival, Transylvania, Romania.

While travelling in Romania, Franck came across a village celebrating
the arrival of spring with a traditional festival. Here she photographed
a pastoral scene with a villager seated on a tree stump playing his clarinet
while two young couples rest on the grass in front of him, the position
of their bodies forming an ideal composition. One of the war photographer
Don McCullin's favourite images by Franck, it captures an idyllic moment
far removed from his own work.

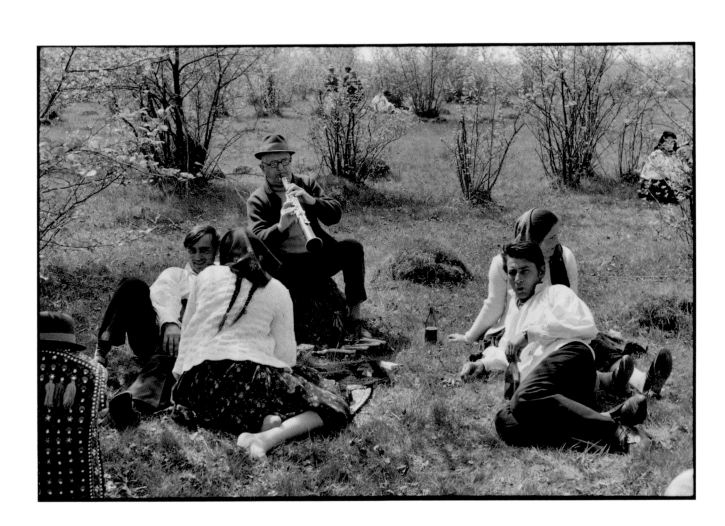

18 1976 Lavender Field, Valensole, Provence, France.

Intoxicated by the scent of lavender as a child, Franck was later astonished to discover field upon field of the fragrant bluish-purple flowers (cultivated by local farmers for their essence) on her first visit to Provence. In this photograph, the stark silhouette of the tree at the end of the sweeping lavender field is framed by the hazy pale grey outline of the hill in the background, which provides a strong keynote to the picture.

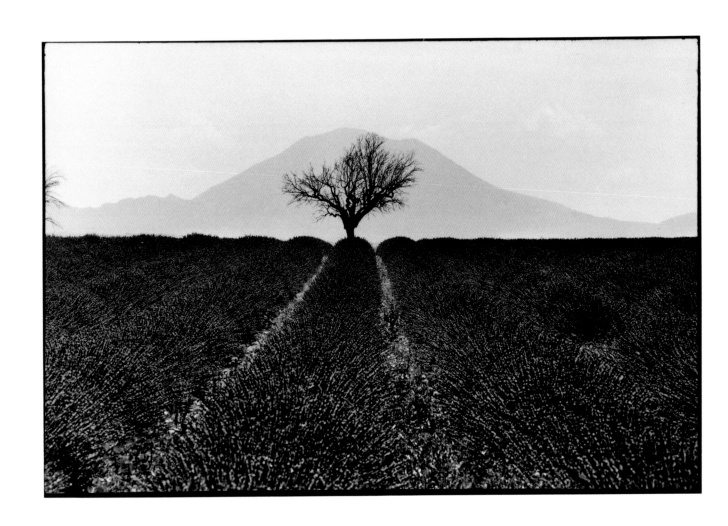

19 1976 | 'Riviera 76' Festival, Le Castellet, France.

This sensuous image is the only nude snapshot Franck has ever taken. Photographed on a very hot afternoon during a three-day music festival in the South of France, a young couple, oblivious to passers-by, stretch out at the edge of a muddy pond, the cooling water lapping at their feet. The classical beauty of their naked bodies is further accentuated by the rather unsightly surroundings.

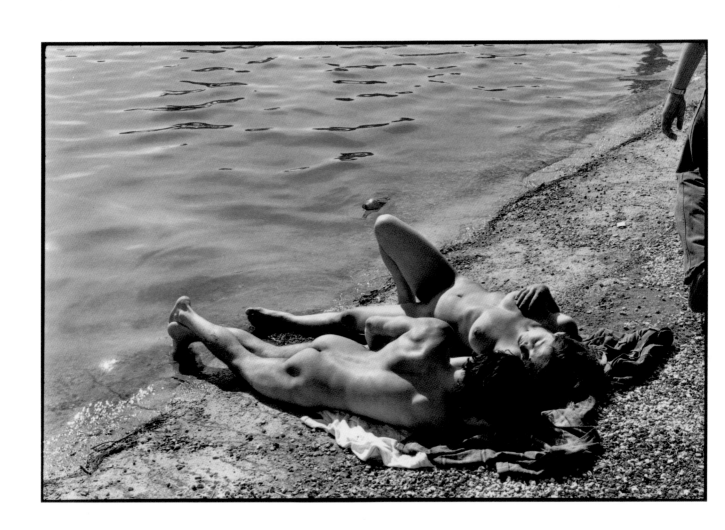

1976 Lili Brik, Hôtel Plaza Athénée, Paris, France.

'Taking someone's photograph is rather like meeting them on a train,' says Franck. 'People reveal themselves, knowing that you will not meet again.' Lili Brik, the subject of this portrait, had been the companion of the Soviet poet Vladimir Mayakovsky. Aware that she has been a beauty, she stares away from the camera, wearing a silk scarf given to her by her friend and admirer, Yves Saint-Laurent. A few years later she committed suicide.

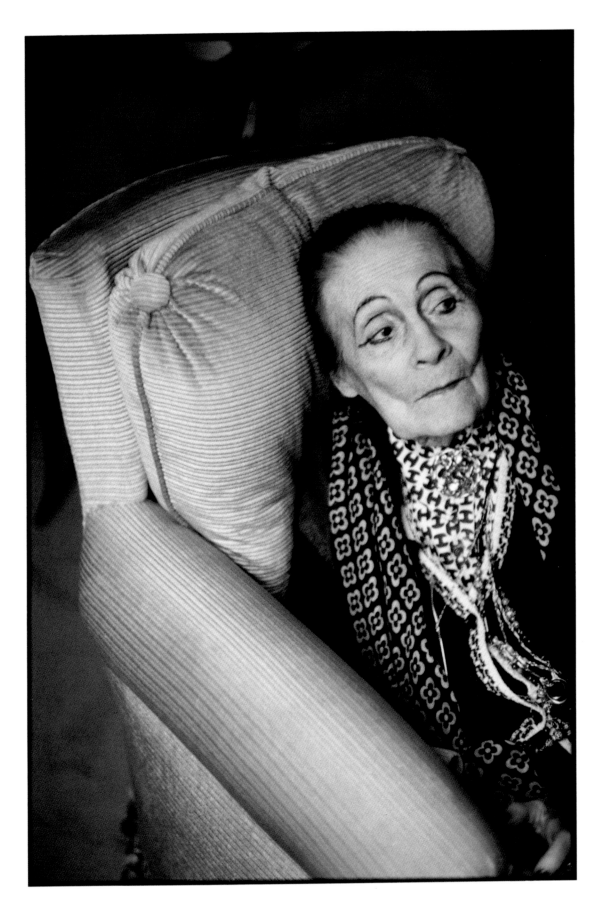

21 1976 Children Playing, Montjustin, Provence, France.

Franck likes photographing children, particularly when they dress up in disguise. Even though they are aware of the presence of the camera, the two photographed here remain unselfconscious as they cavort in a field on a summer's day. The little boy on the left who has half-covered himself with flowers intertwined with leaves, looks like a miniature Roman god taking part in a bacchanalian feast.

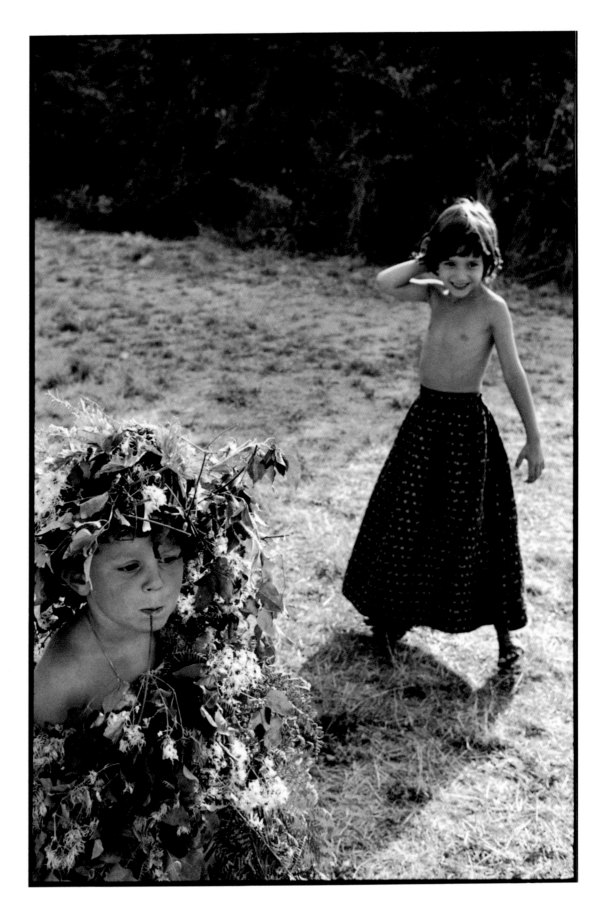

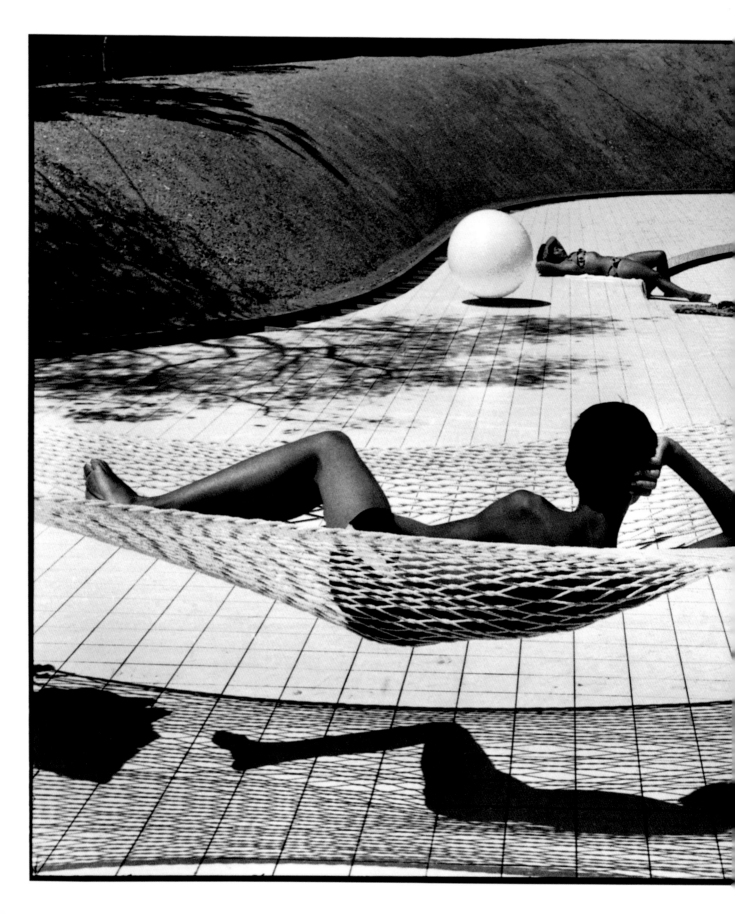

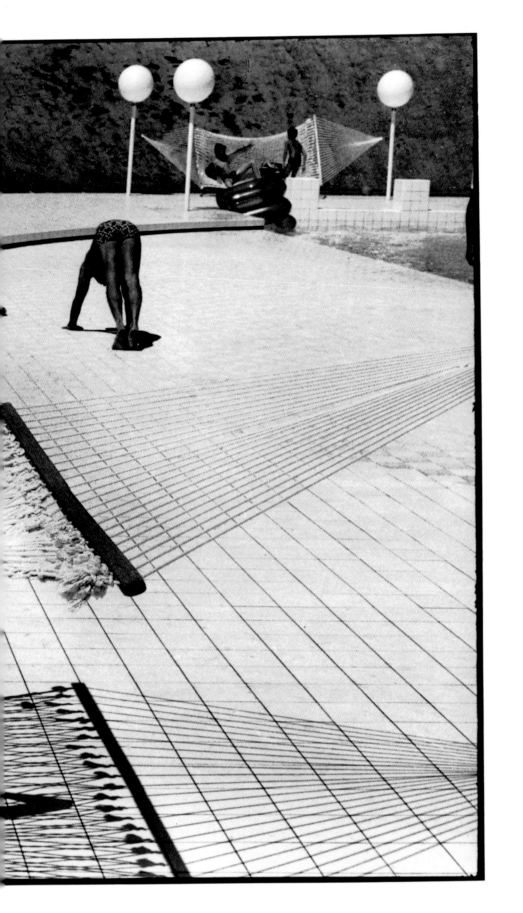

22 *previous page* 1976 Le Brusc, Provence, France.

Perhaps her best-known image, this photograph is an example of Franck's ability to recognize and seize the moment: 'I remember running to get the image, while changing the film in the camera and quickly closing down the lens as the sunlight on the white tiles was so intense – that's what makes photography so exciting,' she says. A second or two later, the perfect composition would have broken up. Unlike the reflective mood of much of her work, this image conjures up a fantasy of idle pleasure.

23 1976 Armistice Day, Wingles, France.

The atmosphere of this photograph, taken on a visit to the war cemeteries of northern France on Armistice Day, is powerfully evocative. A casual glance might lead the viewer to think that the stone statue of the fallen soldier – his heavy legs wrapped in the strips of cloth worn by armies in World War I – is real. The row of veterans casting elongated shadows on the path leading up to the statue complete the visually satisfying composition.

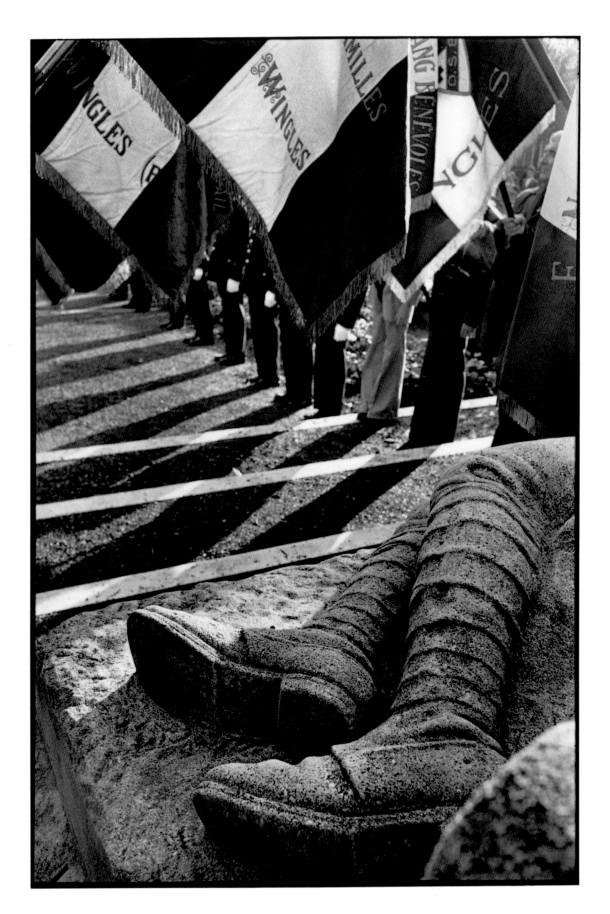

24 1976 Carnival, Limoux, France.

Although she was sent to Toulouse to photograph a political demonstration, when Franck found out that a carnival was in full swing in nearby Limoux, she grabbed her camera and went to have a look. Photographed at night, the revellers – their white masks in sharp contrast with black costumes – form a strikingly beautiful image.

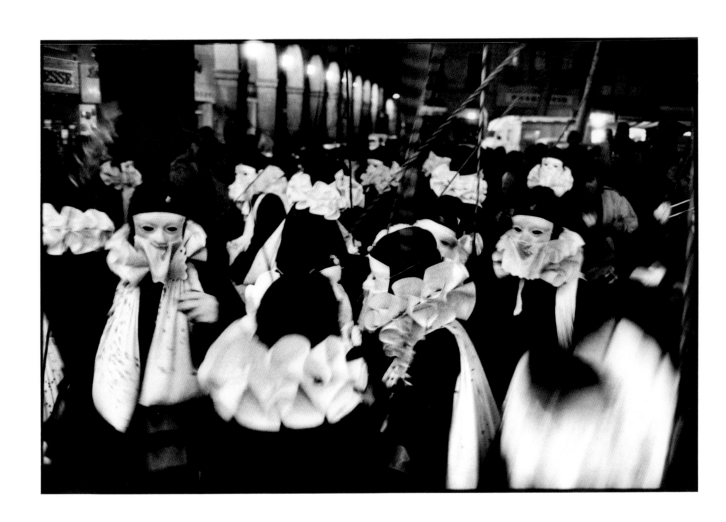

1977 Carnival, Basel, Switzerland.

Franck reveals her fascination with carnivals again in this photograph of a
little girl dressed up as a nineteenth-century lady complete with hat and
veil: 'In Basel, the revelries go on for three days and nights, and everybody
gets swept up.' While the girl looks a little ill at ease in her costume –
Franck remembers she was unable to eat her ice cream – the boy swinging
on the bar of the barrier behind her seems carefree and unconstrained.

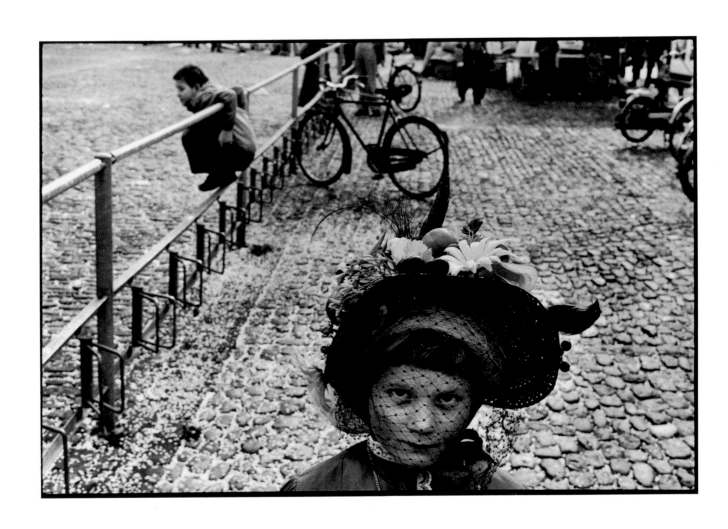

26 1977 Circus School, 3rd *arrondissement*, Paris, France.

This photograph was taken in a former public building in the Beaubourg district of Paris after the old market, Les Halles, had disappeared. A young circus juggler is reflected in a large mirror as he practises his skills, while the marble-breasted figure that forms part of the ornate mantelpiece provides an eye-catching, surrealist touch.

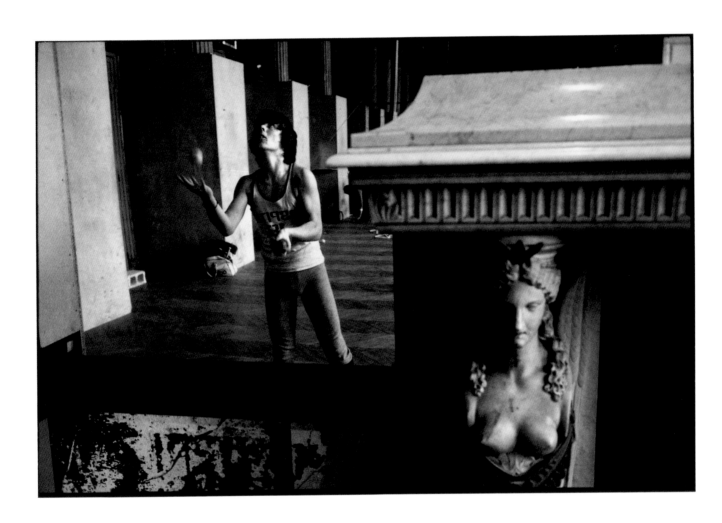

1977 Tuileries Metro Station, Paris, France.

'Photography is a moment in time – you cannot repeat it,' Franck explains. This image, taken in a split second as she was walking past a telephone booth in a Paris metro station, is one such example. An old woman bends over as she looks up a number, while her cat on a lead perches with feline grace on top of the telephone. The booth has long since disappeared.

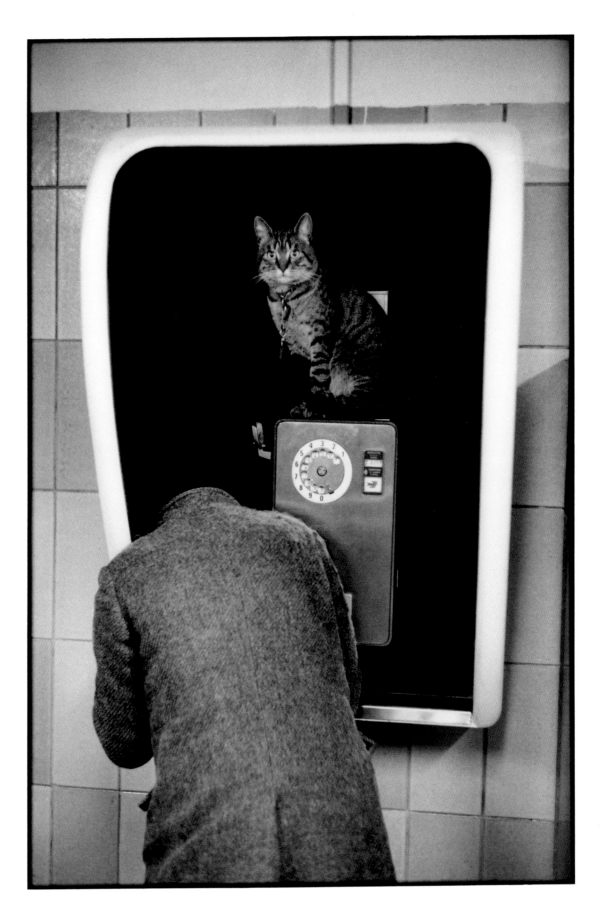

28 1977 Newcastle upon Tyne, England.

Commissioned by the Side Gallery in Newcastle to produce a photographic documentary of the region, Franck spent six weeks in the north of England. 'I remember how friendly the people were, despite the grim conditions in which many of them lived.' In this photograph a group of children, oblivious to their bleak and tattered surroundings on a housing estate outside Newcastle, play on a makeshift tin slide that ends up in a rubbish heap.

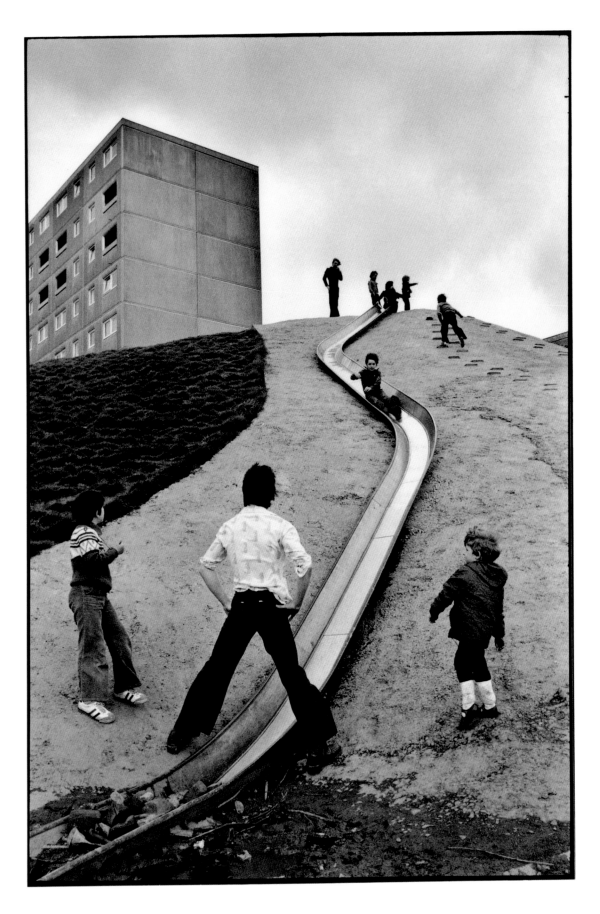

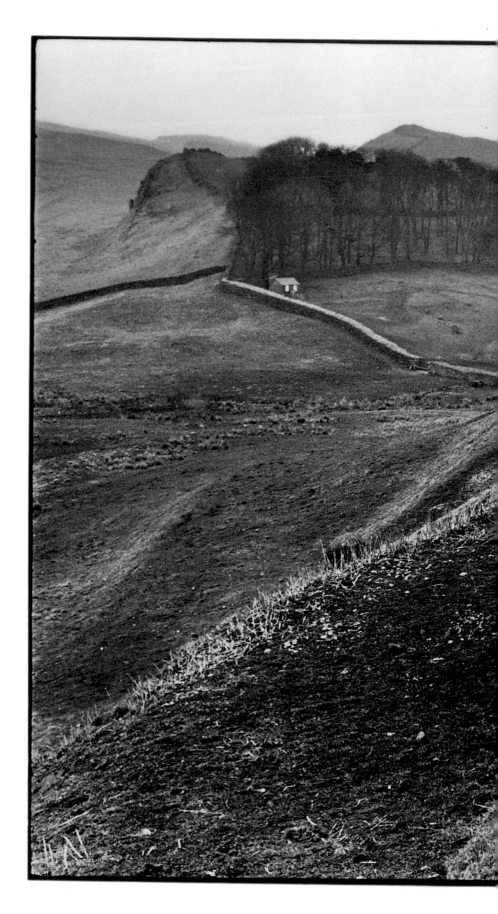

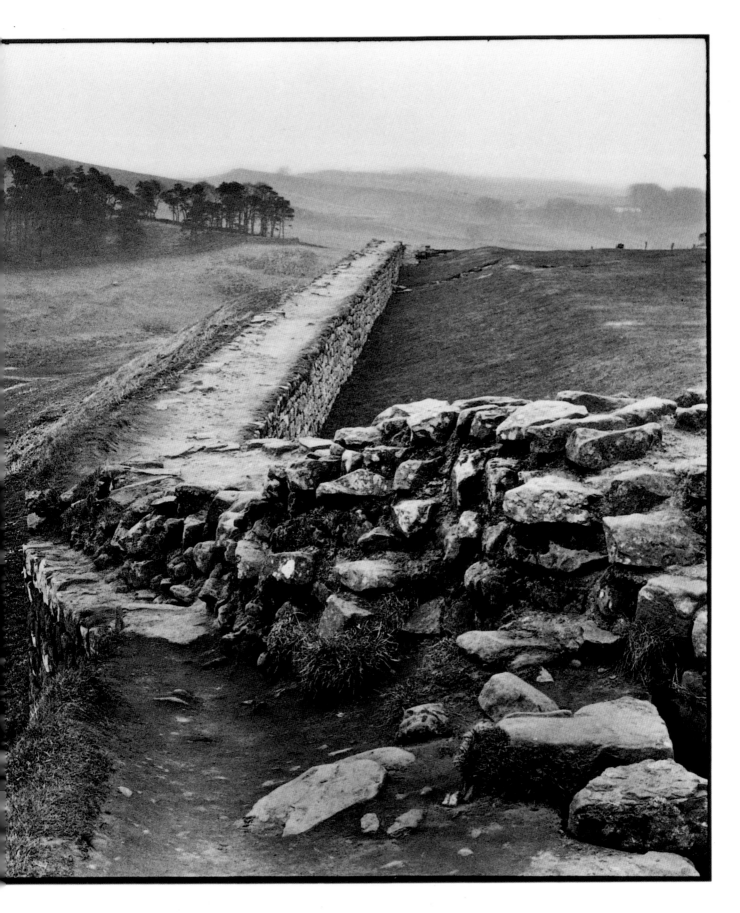

29 *previous page*	1977	Hadrian's Wall, Northumberland, England.

Franck's love of open spaces is reflected in this stark photograph of Hadrian's Wall. Built by the Romans almost two thousand years ago as a defence against northern tribes, the wall in this picture forms the keynote in a harmonious interplay of vertical and horizontal lines.

30	1978	Cemetery, Tynemouth Priory, Northumberland, England.

Both love and death are joined together here in a cemetery near the Northumberland coast. So absorbed in each other that they do not care about being photographed, a couple lies on the grass, surrounded by gravestones blackened with age, which lend a romantic atmosphere to the scene.
A solitary figure in the background looks on with an inquisitive stare.

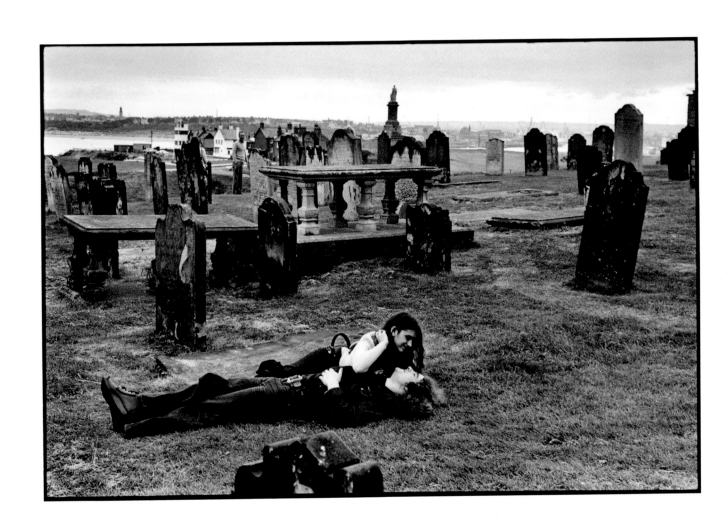

31 1978 Grouse Shoot, Cumbria, England.

In this photograph of a grouse shoot in late August, Franck glimpses the world of English landowners. The figure in plus fours to the right of the picture reveals his class with his confident stride, his gun swung over his shoulder. The dogs in the foreground that look like they are talking to each other complete the image.

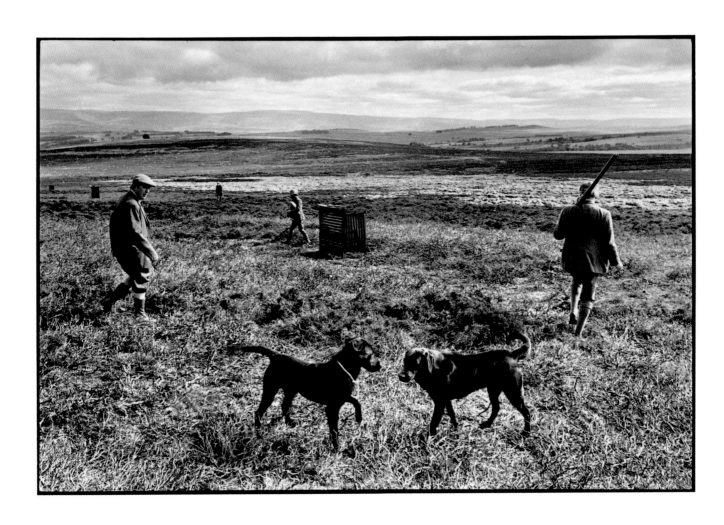

1978 Newcastle upon Tyne, England.

Newcastle went through a period of transformation in the 1960s and
1970s when much of the old back-to-back housing and factories were
pulled down. Here a tinker's horse grazes on rough grass close to the
middle of town with a forest of old cranes in the distance – a desolate
vision of a post-industrial wasteland.

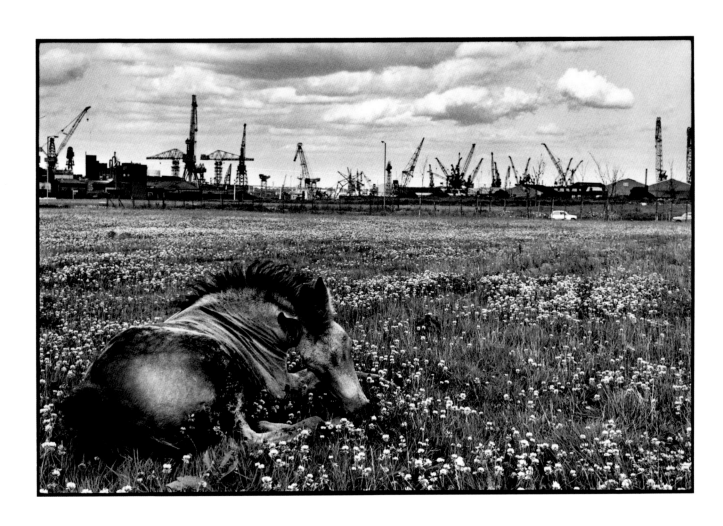

33 1978 Granville, Normandy, France.

Never published before, this is one of Franck's more melancholy images, reminiscent of the work of the nineteenth-century French photographer Gustave Le Gray. Photographed at low tide just before dusk, the harbour wall and the configuration of boats and figures on the shore all fall perfectly into place.

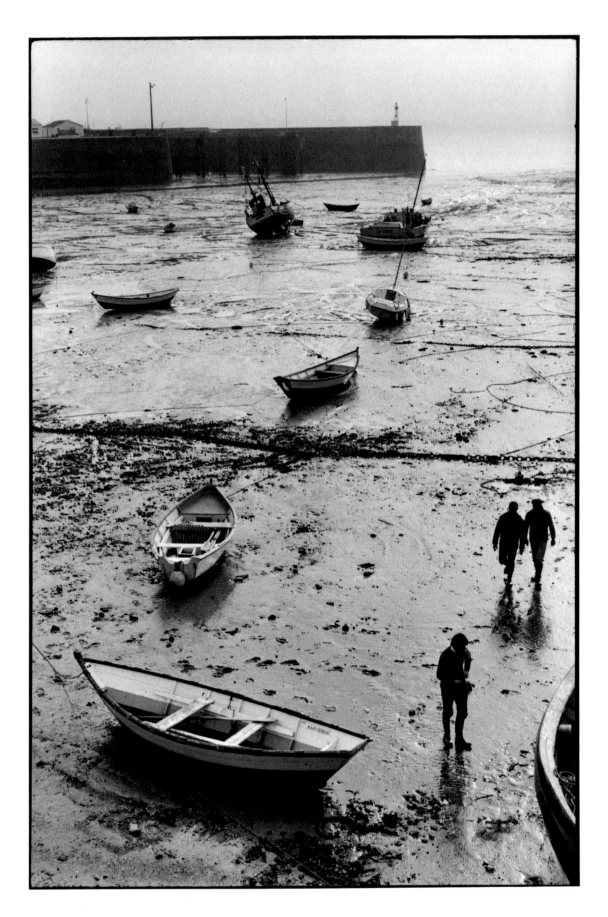

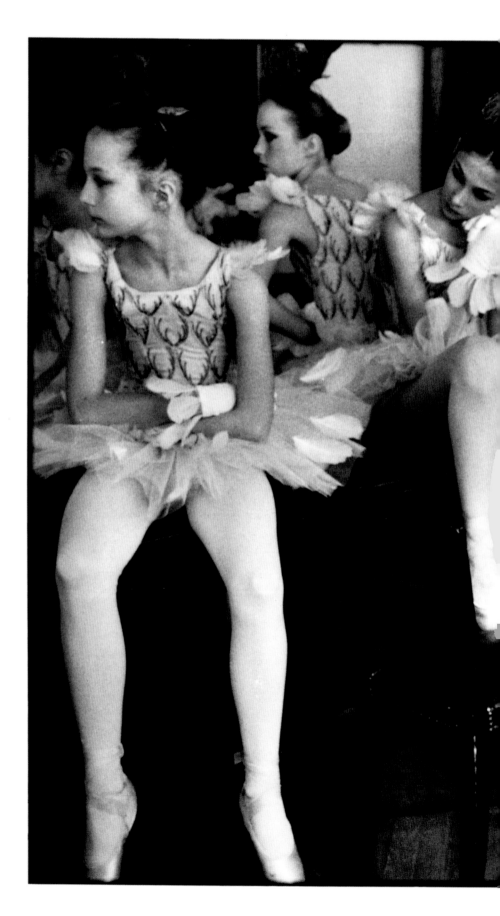

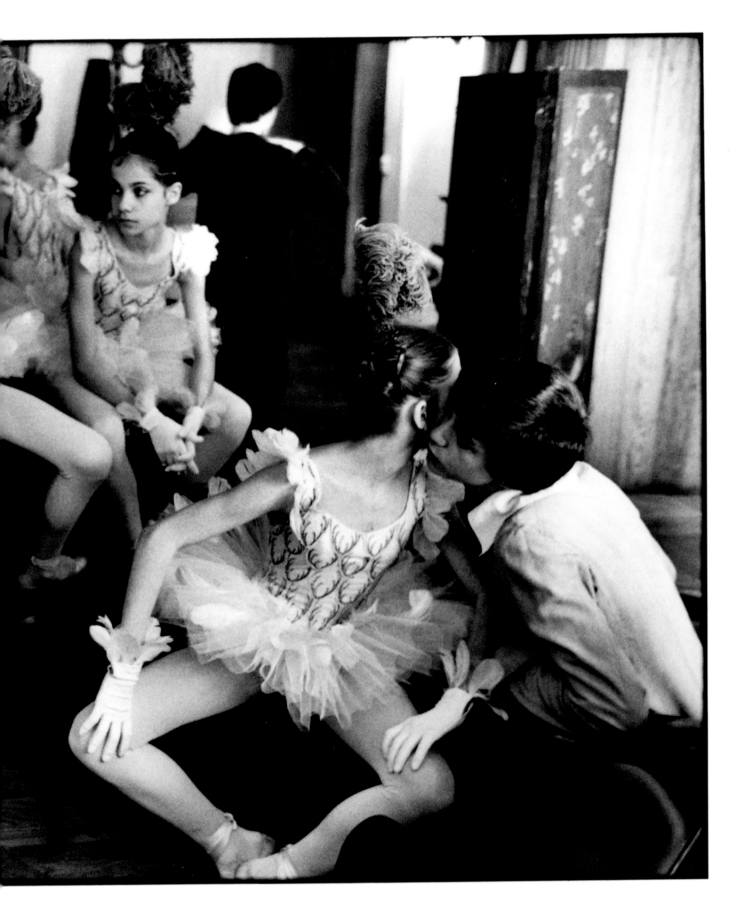

'The ballet teacher at the Paris Opera said to me: "But you can't show this, their legs are open",' recalls Franck. Yet the photograph she took of the nine-year-old dancers relaxing briefly from their regimented existence merely accentuates how their gestures are governed by an unconcerned innocence.

Another 'surprise', Franck took this photograph as her taxi in Bombay passed by a horse and carriage with a young girl staring into space out of the window – a split second later would have been too late. Photography, she says, is often 'a moment that you're ready to receive – or you aren't'.

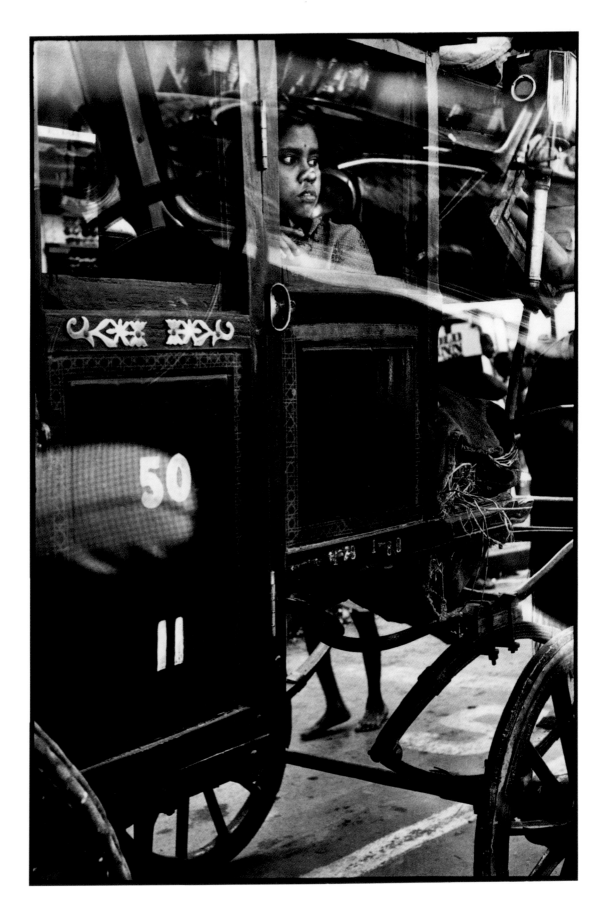

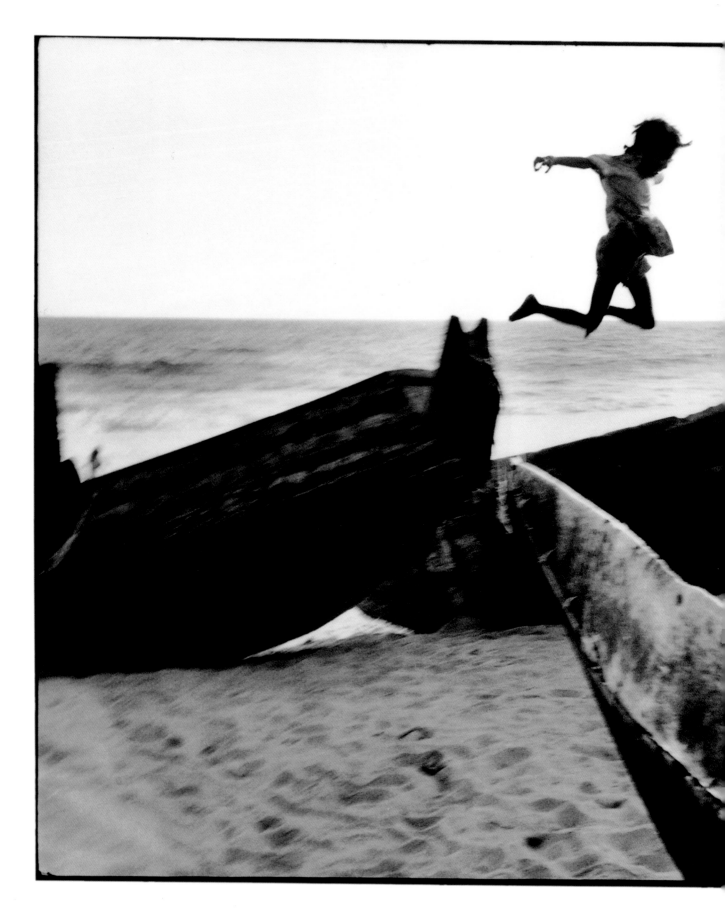

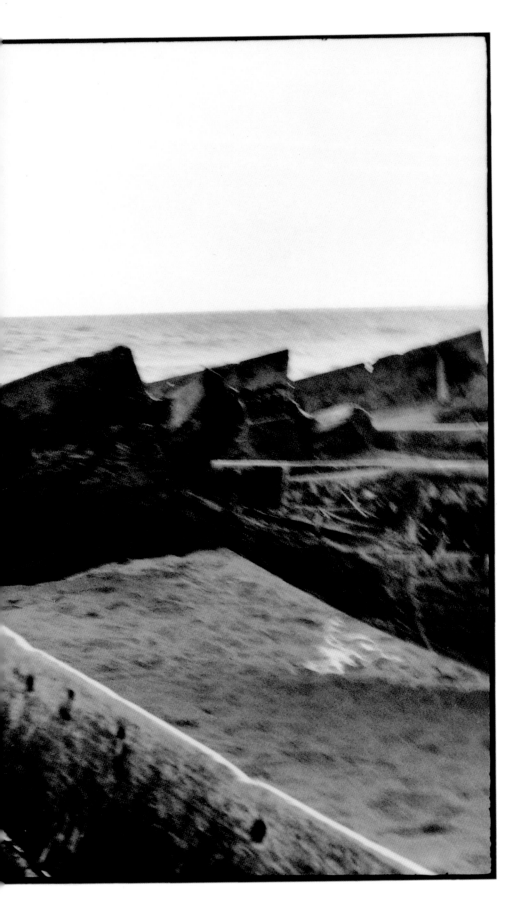

36 *previous page* 1980 Puri, Orissa, India.

Taken in Orissa, one of the poorest states in India, this photograph captures
that universal carefree spirit of youth – whatever the living conditions.
Using some abandoned flat-bottomed wooden fishing boats as a playground,
a child flies through the air as she jumps from one boat to the next, her
dark and slender silhouette expressing the *joie de vivre* that makes this
image so memorable.

37 1980 Marc Chagall, Saint Paul-de-Vence, Provence, France.

Born in Russia in 1887, Marc Chagall settled in France where he became
known for his fanciful paintings of animals, people and objects drawn
from his dreams and from Russian fairy-tales. Franck's portrait of the
ninety-three-year-old artist, taken in his garden, reveals a 'ladies' man'
who enjoys having his picture taken and knows exactly how he wants
to be portrayed. The tree in the background seems as old and venerable
as the artist himself.

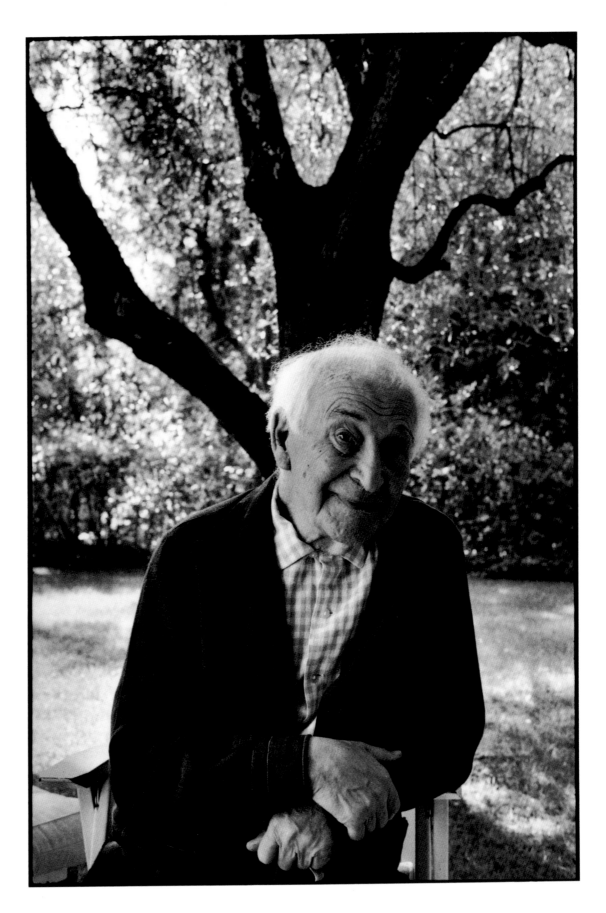

38 1982 Raymond Mason, Paris, France.

Raymond Mason is an English sculptor who has lived in Paris since 1946. He is best known for his brightly coloured life-size figures set in everyday scenes, such as *The Departure of Fruit and Vegetables from the Heart of Paris, 28 February 1969* (1969–71), which is one of several of his works included in the Tate Collection in London. Franck photographs Mason in his studio standing in front of a giant sculpture representing the *vendange* (grape harvest) and wielding the paintbrush he uses to create his vibrant works.

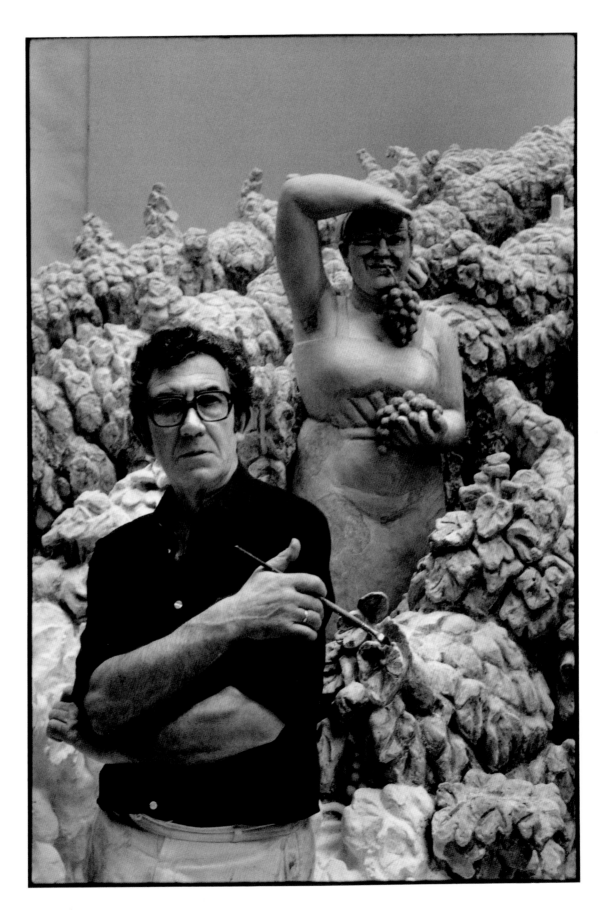

39 1983 Family of Fisherman, Amagansett, Long Island, USA.

In the early 1980s Franck was commissioned to document the Long Island fishing community and its vanishing way of life. In this photograph three young children from a fisherman's family while away the afternoon: 'I was drawn to the way a cardboard box had been transformed into a bed for a little sister. The huge dog must have cost more to feed than the children.'

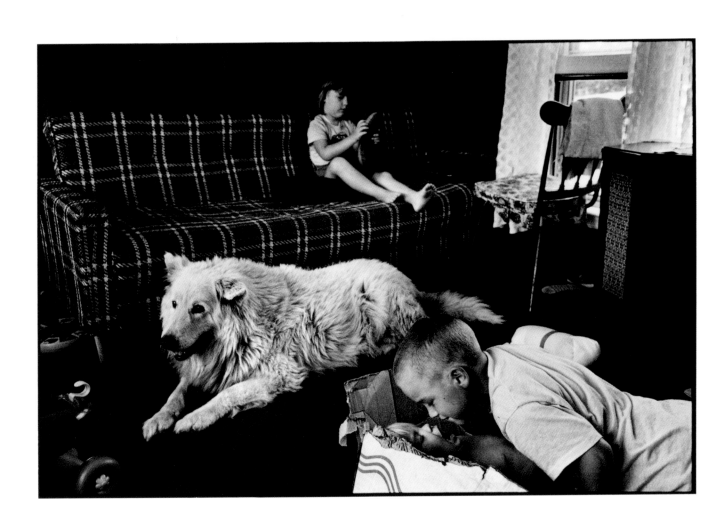

1983 | Bergen, Norway.

'I have never been anywhere where the weather can change so fast – you can almost hear the rain coming,' says Franck of the Norwegian coast. Taking a boat trip up a fjord from Bergen, she had just enough time to take this photograph capturing the effect of the light behind the black clouds. The dark, brooding atmosphere of the image brings to mind the music of the Finnish composer Sibelius.

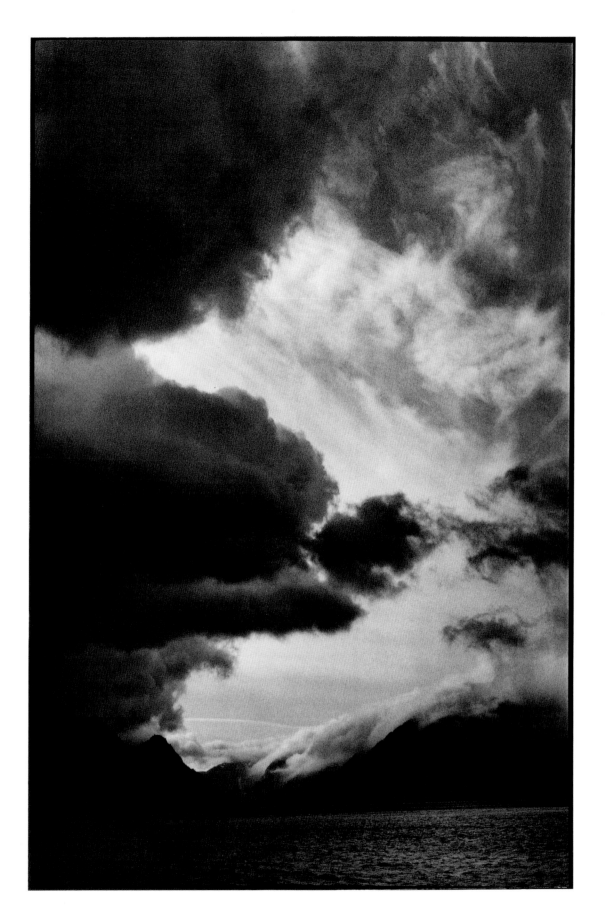

41 1985 | Funfair, Jardin des Tuileries, Paris, France.

It took just a couple of days to assemble this Ferris wheel, which happened
to be outside the bedroom window of Franck's apartment overlooking
the Jardin des Tuileries. Like a human spider in a web high above the
Paris rooftops, a fearless fairground worker with no safety harness adjusts
the bolts as if he were playing with a Meccano set.

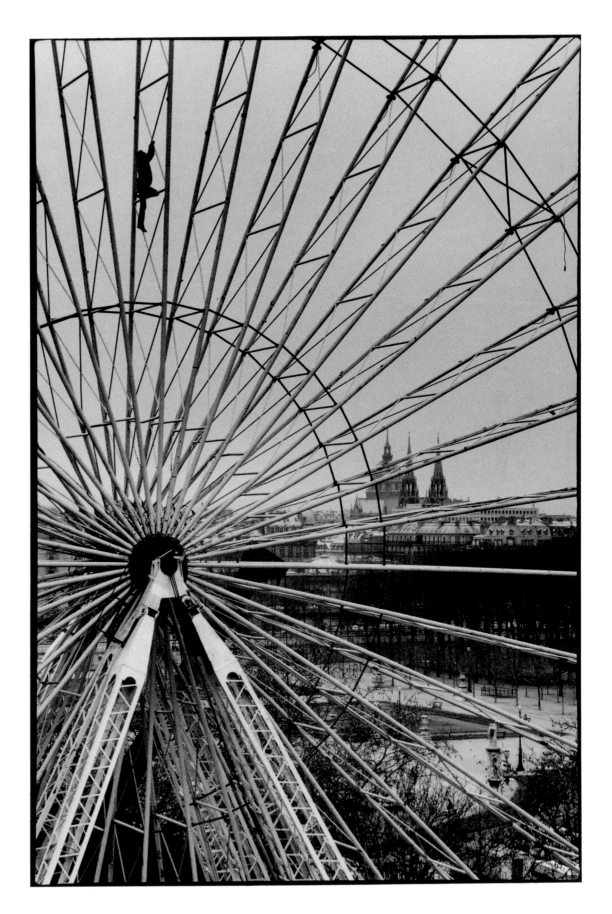

1986 Arsenale Wall, Venice, Italy.

Walking past the old naval dockyard in Venice on a very hot afternoon, Franck spotted the dramatic geometric shapes on the wall created by the shadows of the buildings opposite, which in turn are reflected in the dark mirror-like water of the canal. The effect is both mysterious and inviting.

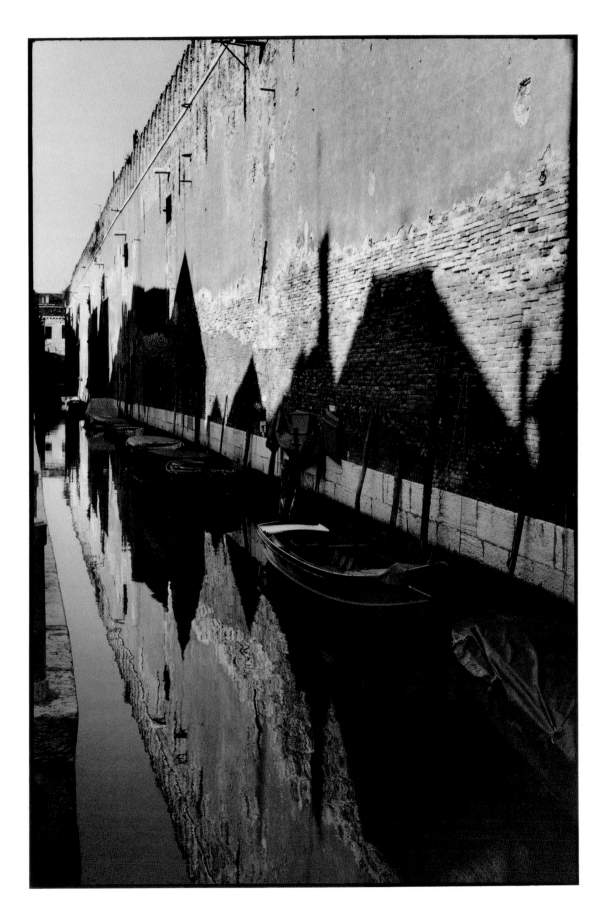

43 1987 Professors from the Collège de France, Paris, France.

The Collège de France was founded in the sixteenth century by François I as an academic force to counteract the all-powerful influence of the Church. Asked by *Paris Match* to photograph its members, Franck rose to the challenge of persuading thirty-eight men and two women to stay absolutely still and look at her: 'For me it was quite a logistical feat because I don't usually work that way.'

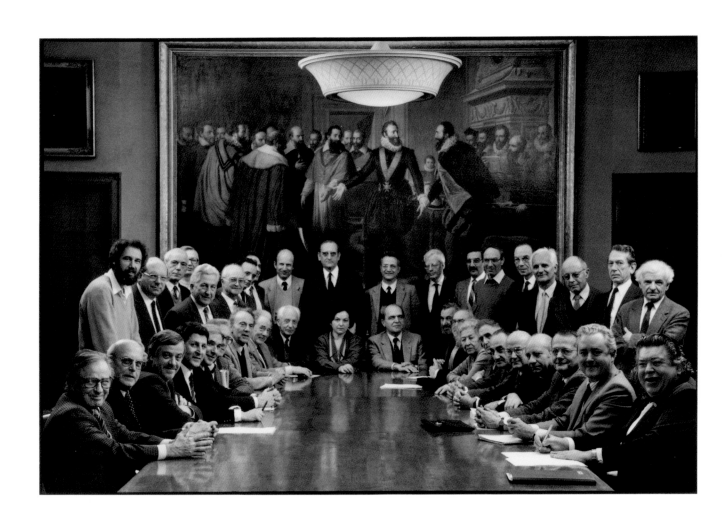

1987 Parc de Sceaux, Ile-de-France, France.

A heavy fall of snow prompted Franck to take this photograph of the box hedges in a park on the southern outskirts of Paris that was designed by the landscape gardener André Le Nôtre in 1670. Typically French in style, their formal, geometric shapes stand out like an abstract painting against the white snow and pale grey sky.

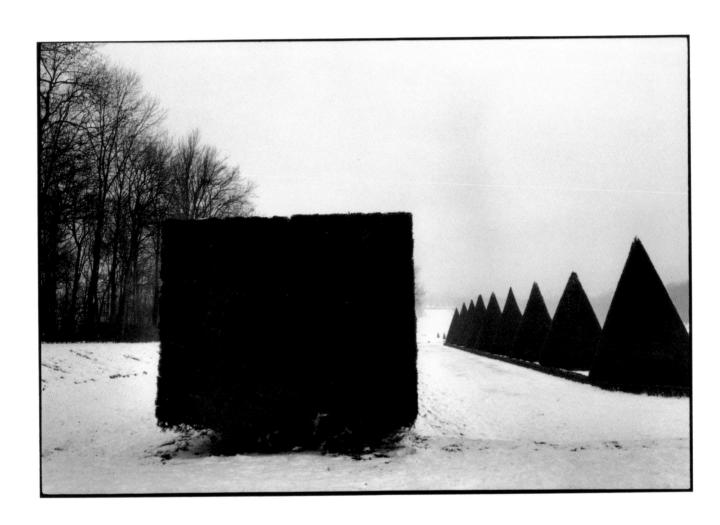

1989 La Grande Arche de la Défense, Paris, France.

This giant sundial, discernible only from above, forms the inner courtyard of La Grande Arche de la Défense, inaugurated in 1989 as one of several 'Grands Travaux' instigated by François Mitterrand. Commissioned for a book, *Les Grands Travaux* (1989) that was made in collaboration with four other Magnum photographers – Ian Berry, René Burri, Richard Kalvar and Marc Riboud – Franck's photograph is almost mathematical in the purity of its composition, with the dark figure walking across the courtyard resembling an ancient Greek statue and emphasizing the foundations of geometry.

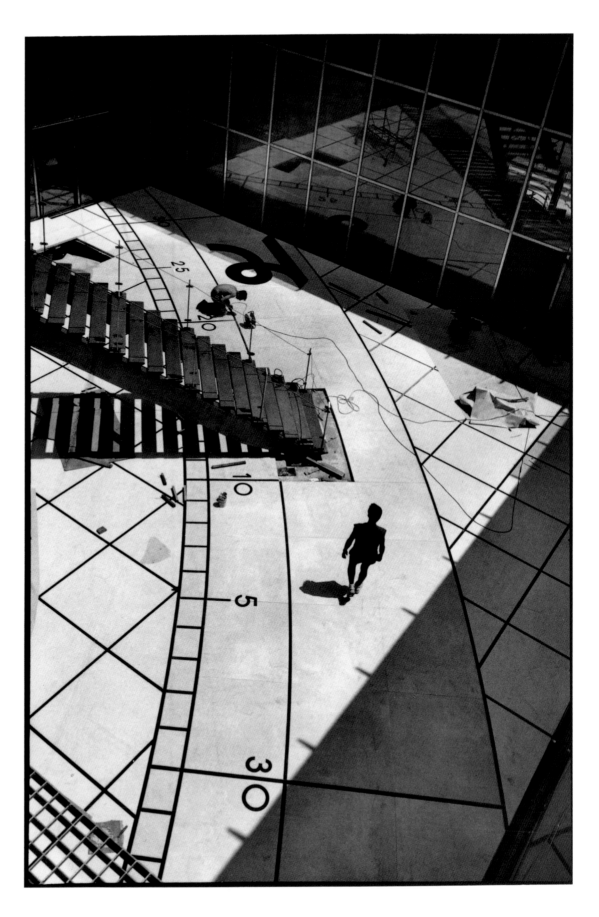

46 1991 His Holiness the Dalai Lama and Abbé Pierre, Dordogne, France.

'This was the first time I met the Dalai Lama and I was taken by his warmth and humour,' recalls Franck, who has often listened to his teachings. This photograph, taken as he grasps the hand of Abbé Pierre (a popular humanitarian figure in France), also reveals the spiritual leader's gentle compassion – a cornerstone of the Buddhist faith.

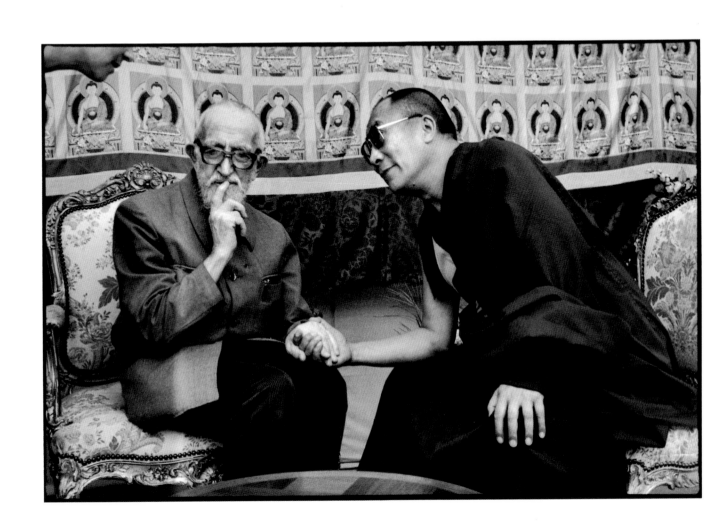

1993 | The Ferry to Tory Island, Donegal, Ireland.

Franck first went to Tory Island, off the north-west coast of Ireland, on the suggestion of her friend Derek Hill, an English painter, who passed away in 2000. Fascinated by its close-knit Gaelic population, she has made a record of a struggling community. Here she photographs a dramatic sky from the ferry that brings in supplies from the mainland: 'The weather is less changeable than in Bergen, but there are exciting seas and terrific storms – the elements are very present.'

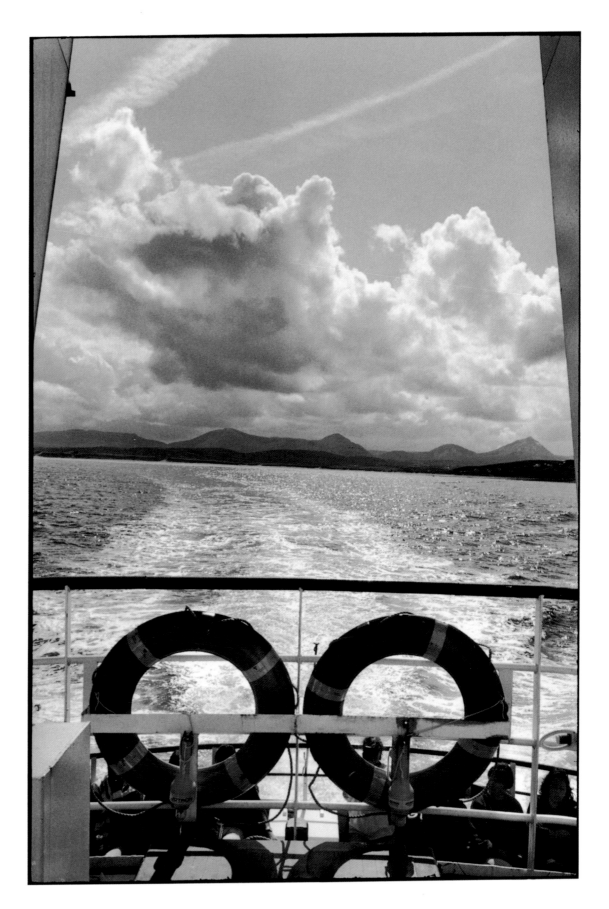

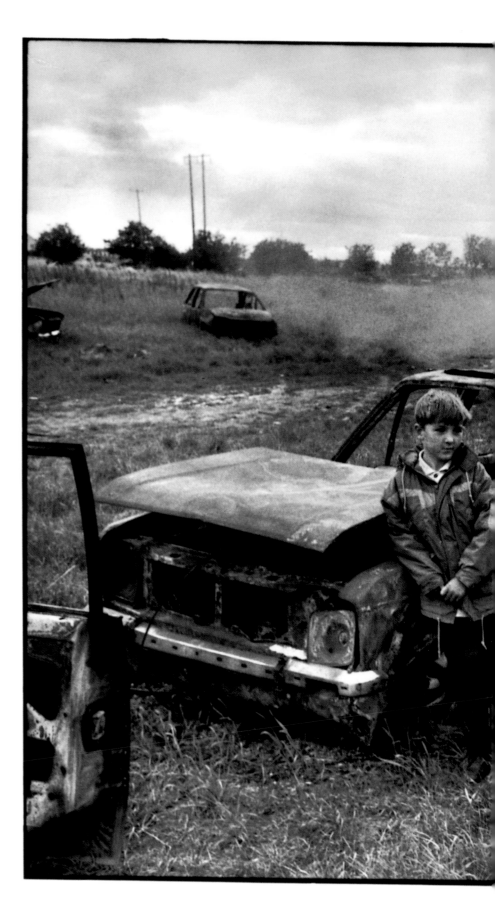

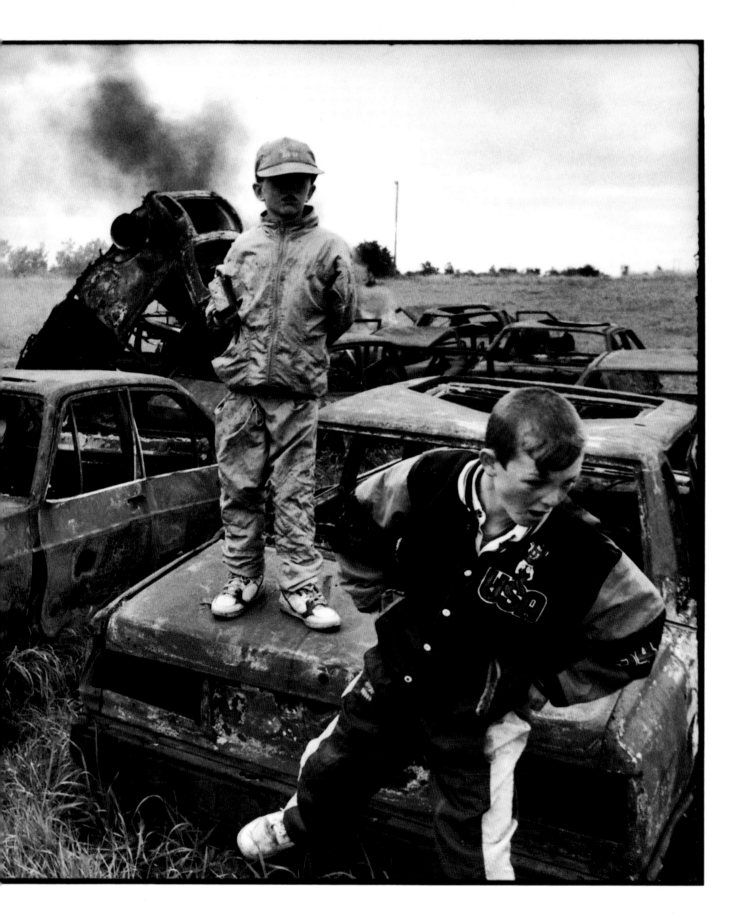

48 *previous page* 1993 Darndale Housing Estate, Dublin, Ireland.

In a rough suburb of Dublin, three boys play among the smoking wrecks of stolen cars that have been raced around the field and then set alight. Happy to be photographed because they know they are too young to be accused of theft, the triangular pose with one boy standing on top of a car lends structure to the image.

49 1995 Tory Island, Donegal, Ireland.

Franck's gift for capturing the carefree exuberance of childhood is also apparent in this photograph of two little girls jumping hand in hand off a wall into the sand: 'It was one of those rare warm days on Tory Island when I spotted the two girls. I remember they took such delight in jumping off that wall over and over again.'

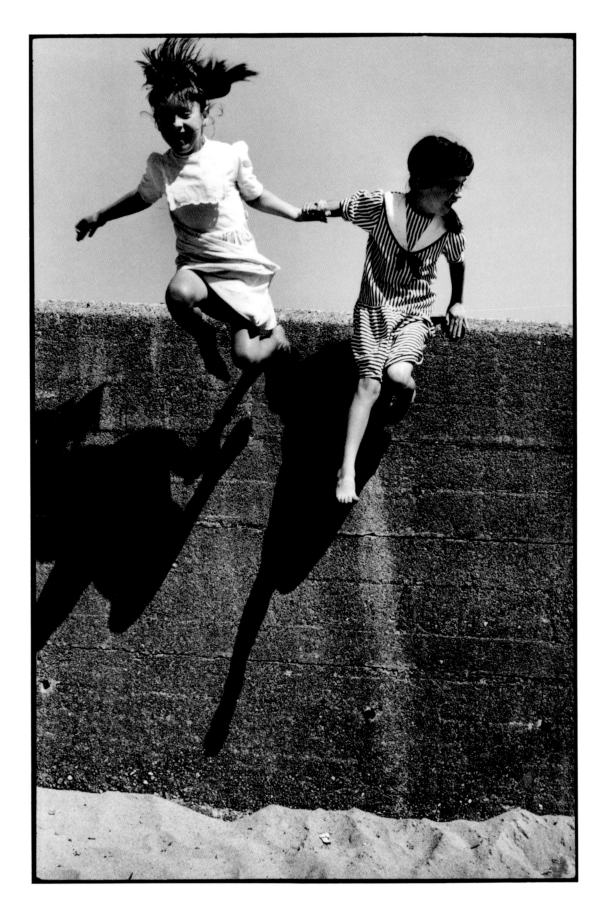

1996 Tulku Khentrul Lodro Rabsel (aged 12) with his tutor Lhagyel,
Shechen Monastery, Bodnath, Nepal.

Having met the Dalai Lama, Franck travelled to a monastery in Nepal.
The tulku (a Tibetan Buddhist reincarnated lama) in this photograph was
discovered when he was three and entered the monastery at the age of five
where he was given his own tutor. 'I came into the room just as a pigeon
alighted on the monk's head, much to his pupil's delight. Fortunately,
I happened to have the right lens on my camera.' A well-known and
much-loved image, this photograph was published in both *Paris Match*
and *Marie Claire* in 1999.

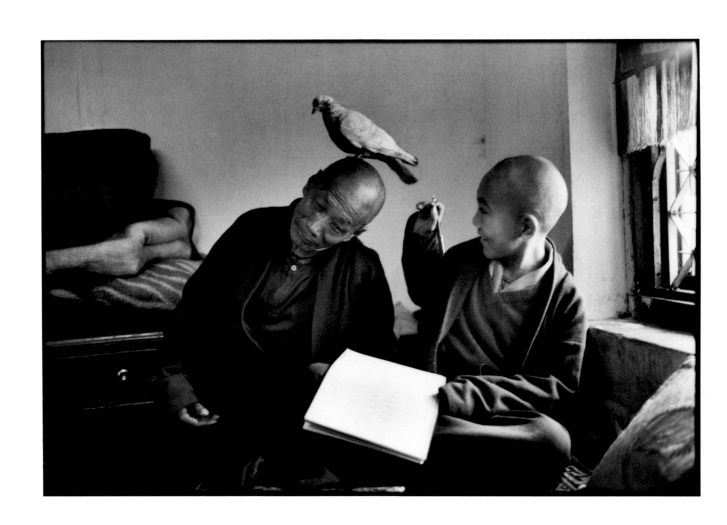

51 1996 Tibetan monks debating, Sera Monastery, Karnataka, India.

Part of Franck's series of photographs on daily life within the Tibetan monasteries of India and Nepal, this image shows the Buddhist monks gathered together for one of the regular debating sessions that continue day and night for three weeks. A participant who answers questions or argues incorrectly is physically provoked by his fellow monks – a playful ritual with specific rules of engagement.

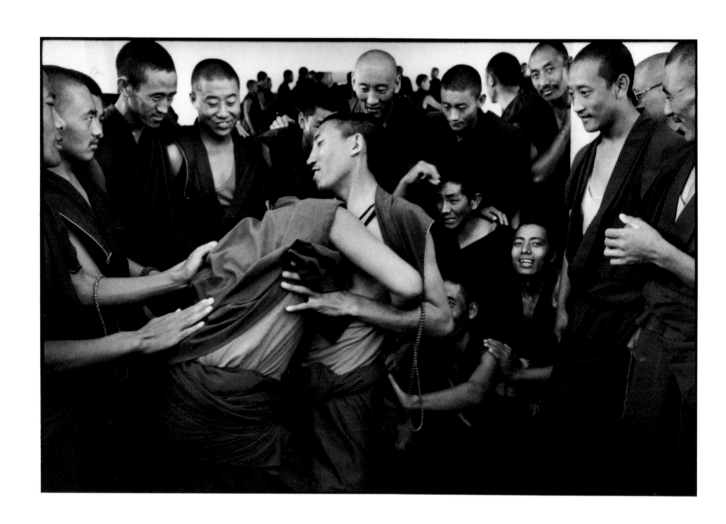

1996 Seamus Heaney, Dublin, Ireland.

Franck took this unusual photograph of the Nobel Prize-winning Irish poet Seamus Heaney at his home, following a long walk together by the sea. An approachable man, he holds up a portrait of himself by their mutual friend, Derek Hill, thus offering the viewer another interpretation of himself.

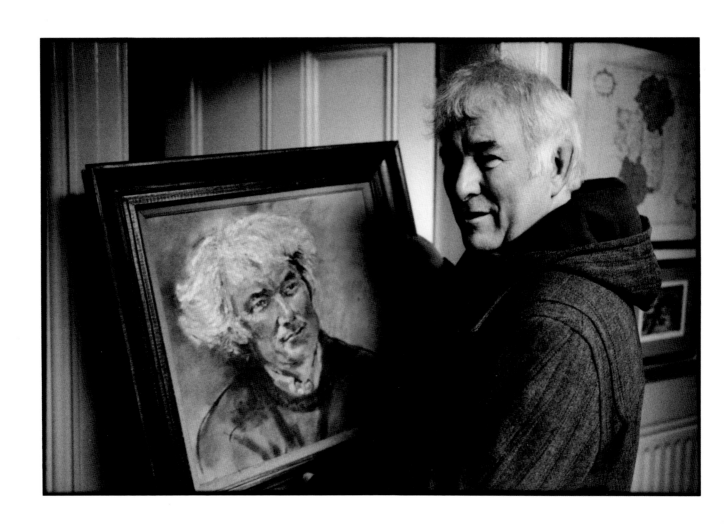

53 1996 Wedding, Gweedore, Donegal, Ireland.

This photograph of a young bride from Tory Island with her veil billowing in the breeze as she trips down to the beach for the wedding pictures, suggests that no money has been spared: 'I was astonished at the lavishness of the occasion,' recalls Franck. 'They had even managed to save up for a sit-down lunch for the whole village – it was almost like a Sicilian wedding.'

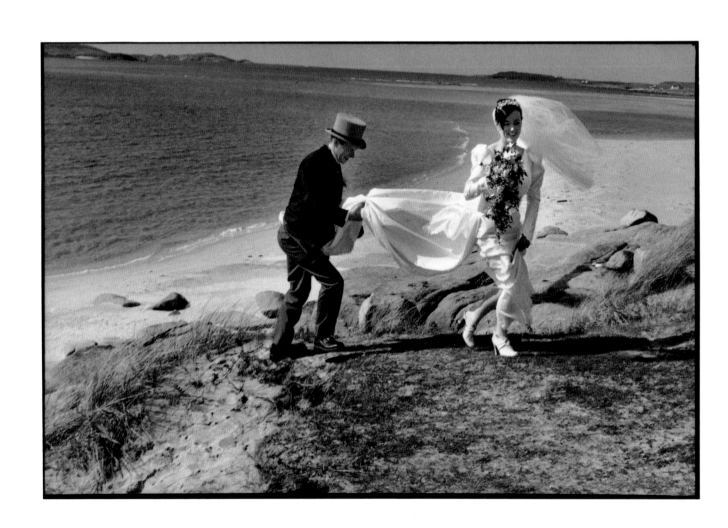

1999 Balthus, Rossinière, Switzerland.

Unlike many modern artists, Balthus avoided the celebrity machine, refusing for many years even to be photographed. Towards the end of his life, however, he became almost eager to have his picture taken. In this photograph he reveals his lifelong affection for cats as he strokes his Burmese with his elegant fingers. Eighty years earlier, as an eleven-year-old boy, Balthus made forty ink drawings about the adventures of his cat displaying a prodigious talent that was spotted by the poet Rainer Maria Rilke.

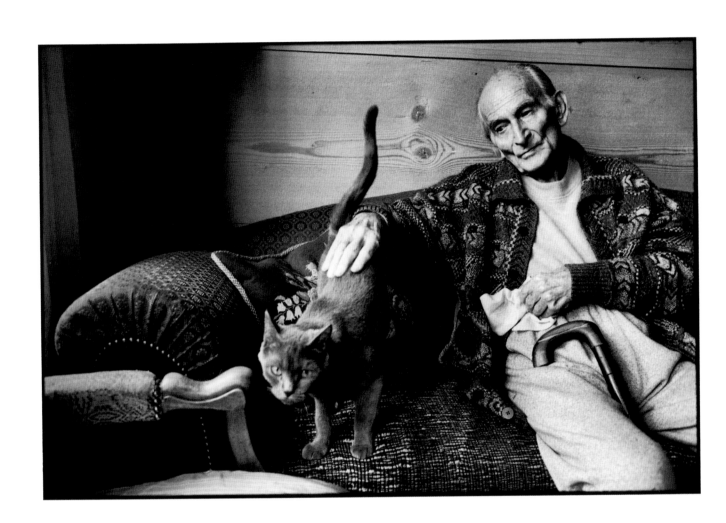

55 2000 Rehearsal, Ballet Moïsseev, Moscow, Russia.

In early 2000 Franck travelled to Moscow to photograph Russian gymnasts, dancers and circus performers. The nine-year-old dancers in this photograph, who look like paper cut-outs, are trained with relentless discipline. The girl in the centre droops her head from sheer exhaustion – a human touch that makes the photograph so successful.

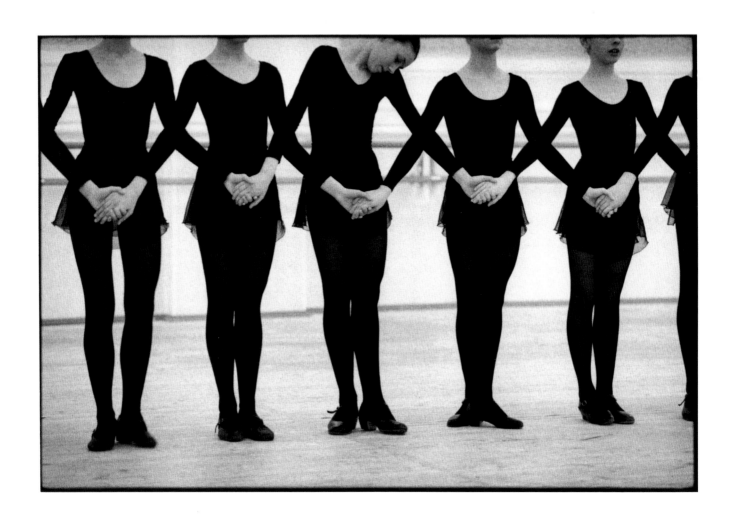

1938	Born in Antwerp, Belgium.
1940–44	Moves to the United States when her father joins the British Army in World War II, then settles in London with her family.
1960–63	Studies History of Art at the University of Madrid and the École du Louvre in Paris.
1964	Goes on sabbatical to China, Japan, Hong Kong, Cambodia, India, Afghanistan and Turkey. Returns to Paris to work as photography assistant at Time-Life.
1970	Becomes freelance photographer and joins the VU photographic agency.
1971	Marries Henri Cartier-Bresson. Makes two documentary films in the United States, *Music at Aspen* and *What has Happened to the American Indians?* Returns to Paris before the agency closes down later that year. Exhibition on Ariane Mnouchkine's theatre cooperative opens at the Galerie Rencontre in Paris and is published as *Le Théâtre du Soleil.*
1972	Co-founder of the VIVA photographic agency in Paris.
1979	Leaves the VIVA photographic agency to focus on her project on the elderly. Exhibits her work at the Portfolio Gallery in Lausanne, Switzerland and at the Side Gallery in Newcastle upon Tyne, England.
1980	Work on the elderly is exhibited at Galerie Agathe Gaillard, travels in Europe and is published as *Le Temps de viellir* with an introduction by Robert Doisneau.
1981	Exhibition 'Le Temps de vieillir' is shown at Musée Nicéphore Niépce in Châlon-sur-Saône and travels in France and on to Sweden.
1983	Becomes a full member of the Magnum photographic agency.
1985	Begins working with 'Les petits frères des Pauvres', a charity for elderly people based in Paris. Solo exhibition 'Vingt Contemporains vus par Martine Franck' opens at the Centre Georges Pompidou in Paris.
1988	Exhibition on her portraits opens at the Nikon Gallery in Zurich, Switzerland and is published as *Portraits* with a preface by Yves Bonnefoy. Publication of her second monograph on old age, *De temps en temps.*

1989	Exhibition 'De temps en temps' opens at the Centre National de la Photographie in Paris.
1995	Collaborates with Robert Delpire on the film *Ariane et Compagnie: Le Théâtre du Soleil*.
1998	Becomes vice president of Magnum Paris for two years. Major retrospective held at the Maison Européenne de la Photographie in Paris and travels in Europe and the United States. Exhibition featuring Franck's portraits of Cartier-Bresson is held at FNAC Ternes in Paris
2000–01	Project on Tibetan tulkus is exhibited at Rossi & Rossi Gallery in London and Tibet House in New York, and is published as *Tibetan Tulkus: Images of Continuity*. Exhibitions held at the Galerie Claude Bernard in Paris and the Peter Fetterman Gallery in Santa Monica, California.
2002	Major exhibition held at the Musée de la Vie Romantique in Paris.
2003	Creates the Fondation Henri Cartier-Bresson with her husband and daughter Mélanie to preserve and share the legacy of his work.
2004	Henri Cartier-Bresson dies. Photographs the productions of the American avant-garde theatre director, Robert Wilson at the Comédie-Française in Paris.
2005	Contributes to the exhibition 'Euro Visions' featuring photographs from the ten countries that joined the European Union in 2004 by ten Magnum photographers, held at the Centre Georges Pompidou in Paris, before travelling on to Milan, Budapest, Warsaw and Brussels.
2006	Exhibition on her portraits held at the Galleria dell'Incisione in Brescia, Italy

Phaidon Press Limited
Regent's Wharf
All Saints Street
London N1 9PA

Phaidon Press Inc.
180 Varick Street
New York NY 10014

www.phaidon.com

First published 2007
© 2007 Phaidon Press Limited

ISBN 978 0 7148 4781 8

Portrait of Martine Franck
© Willy Ronis/Rapho

Designed by Pentagram
Printed in Singapore